GLOUCESTER MASSACHUSETTS

NEW DESIGN
LONDON

series editor: **Edward M. Gomez**

THE EDGE OF GRAPHIC DESIGN

ROCKPORT PUBLISHERS

FIRST PUBLISHED IN THE UNITED
STATES OF AMERICA BY:
Rockport Publishers, Inc.
33 Commercial Street
Gloucester, Massachusetts 01930-5089
Telephone: (978) 282-9590
Facsimile: (978) 283-2742
www.rockpub.com

ISBN 1-56496-756-5
10 9 8 7 6 5 4 3 2

Printed in China.

Design: Stoltze Design
Cover Image: Photodisc

NEW DESIGN
LONDON

ROCKPORT

Acknowledgments

Special thanks for valuable research and background information go to these sources and contacts in the United Kingdom: Emily Hayes, head of design promotion at the British Council; Esther Gibbons at British Design & Art Direction; André Collins at the Design Business Association; Gerard Forde at the Design Museum; Helen Cornish at the International Society of Typographic Designers; and Angela Beavers at the Chartered Society of Designers. In New York, thanks go to the Information Services staff at the British Consulate.

I also thank my literary agent, Lew Grimes, for his energy and insight; and, at Rockport Publishers, editors Alexandra Bahl, Ellen Westbrook, and Shawna Mullen for their contributions to this volume of the *New Design* series.

Most of all, on behalf of everyone involved in the production of *New Design: London*, I thank the many cooperative, thoughtful, and enthusiastic graphic designers who kindly have shared their work and their ideas with us, and who have allowed us to reproduce them here.

CONTENTS

Some three decades after Beatlemania, Carnaby Street, and the hysteria of the miniskirted, bell-bottomed "British invasion" rocked America and infused a still-nascent, global pop culture with curiously accented, dandy-defiant style, "Swinging London," as *Time* famously dubbed in 1966 the ancient hometown of legendary colonizers and kings, is swinging again. Or so the trend-chasing mass media on both sides of "the pond" and the United Kingdom's New Labour government itself, with its catchy "Cool Britannia" sloganeering, would have Britons and foreigners alike believe.

Still, something essential has been overlooked in the distinctly postmodern, government attempt to brand a country with all the polish and time-tested techniques of skilled marketers. And in the way the media have responded breathlessly and on cue. That is, quite simply, that "swinging" London never really left. Never mind, for starters, the non-stop permutations of sounds, from glam-rock to punk to rave-fueling house, that have

Music-club flyer
ART DIRECTOR: Robbie Bear
DESIGNER: Robbie Bear

poured out of here, keeping British pop music perennially front and center on the world stage; in recent decades, in the design arts, too, this major center of research and innovation has consistently brought forth new ideas that have affected everything from magazine publishing to restaurants and retailing. And designers the world over have been paying attention.

London in the late twentieth century doesn't just swing—it buzzes, throbs, hums and

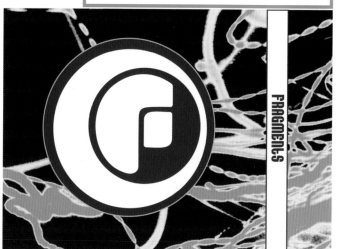

Fragments Records collateral material
ART DIRECTOR: Mitch
DESIGNER: Mitch

pounds with an infectious energy that, from one imaginative design effort to the next, is helping to build a vision of the much-ballyhooed "new" Europe with more ingenuity and flair than even some longtime Britain-watchers may recognize. New Yorkers may be proud of their "city that never sleeps"; across the sea, steeped in tradition and with an eye on the promises of a new century just around the corner, Londoners get the job done, sleep—the Underground, famously, is not a 24-hour affair—and may even find time to take afternoon tea.

All of the powerful, important aspects of visual communication that work in concert with advertising, publishing, retailing, architecture, transportation and tourism, fashion, and, yes, even government, have played their vital roles in the eruption of activity that has made "British design" a potent force and not just a name. Consider just a few examples of this creative outpouring during the past two decades, including Neville Brody's inventive typography for the 1980s style magazine *The Face*; the emergence of such design-focused publications as *Blueprint, Eye,* and *Wallpaper**; the trend-setting interiors and visual-identity programs for large retailers like Virgin Megastores; the Design Museum, the revitalization of London's riverfront, and the infusion of investments and ideas that design impresario and restaurateur Sir Terence Conran and his collaborators have made there;

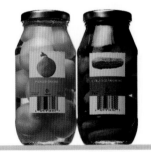

Packaging for foods marketed by Conran Design Partnership
DESIGN: CD Partnership with Morag Myerscough
DESIGNERS: Morag Myerscough, Dan Thomas, Charlie Thomas
PHOTOGRAPHER: Alan Newnham
ILLUSTRATOR: Elizabeth Frazer Myerscough

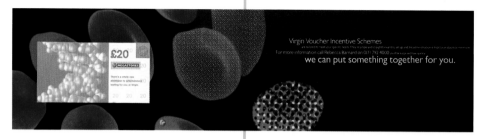

Virgin Megastores brochure
CREATIVE DIRECTOR: Iain Crockart
DESIGNER: Simon Elliott
VOUCHERS, CREATIVE DIRECTOR
AND DESIGNER: Iain Crockart

Richard Rogers's Lloyd's Building, Colin St. John Wilson's new British Library at St. Pancras, the reconstructed Globe theater, and new construction or renovations in nearly every district of London; and, thanks to the likes of Paul Smith, Vivienne Westwood and Alexander McQueen, the city's bold reclaiming, from Milan and Paris, of its erstwhile title as Europe's fashion capital.

As in Tokyo, Los Angeles, or Paris, design studios in London turn up in every configuration. Some are large and corporate in mindset and structure, with the resources to produce consistently slick work. Others are small outfits of from one to a dozen or so ambitious, risk-taking comrades in arms who take aim against the blandness of conventional, anonymous design. Like their counterparts in other media centers around the world, they are helping to define more clearly the graphic designer's role as author of a style or of a mode of communicating visually that has its own strong, distinctive voice. Often they must—and with impressive results, do—stretch limited budgets for smaller jobs during the early stages of their careers to make the most of less-costly materials and production methods. And thanks to cellular phones, portable computers and the new entrepreneurial spirit of the age upon which creative types have seized, self-employed, itinerant designers who work alone or hop from one studio to another, depending on where the work is, also have become a significant breed.

"We enjoy the freedom and the variety of projects that so far have come with being a small company," notes Jayne Alexander, who, with Violetta Boxill, is one-half of Alexander Boxill Visual Communication. Their neat, uncluttered little studio, outfitted with computers, is located in the Clerkenwell district of

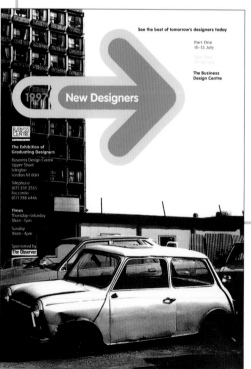

"New Designers" program
ART DIRECTORS: Jayne Alexander,
Violetta Boxill
DESIGNERS: Jayne Alexander,
Violetta Boxill

east-central London. This neighborhood has become a center for designers and craftspeople of all stripes.

"The learning experiences have been very interesting, too," Boxill wryly observes, recalling how printing companies and other service providers with whom she and Alexander have worked at first thought, from the sound of their company's name, that it was owned and operated by a man. "We've acquired a lot of knowledge very quickly, on the job, and it all has gone right back into our work." Like other designers who savor a sense of independence and whose portfolios reflect it, Alexander and Boxill often shoot their own photography and create their own typefaces for their projects. Like many other young talents on the London

100 Watt typeface for Royal College of Art poster
ART DIRECTORS: Jayne Alexander, Violetta Boxill
DESIGNERS: Jayne Alexander, Violetta Boxill

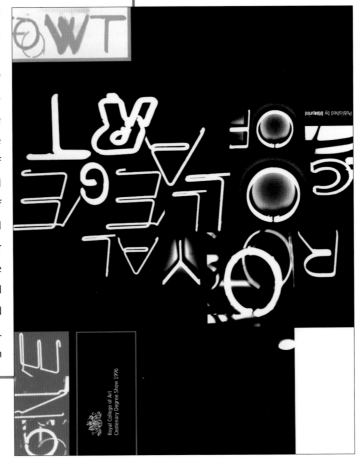

scene, they met at the Royal College of Art (RCA) and, after graduation, developed a professional partnership.

With renowned post-graduate programs (equivalent, in the United States, to those at the master's-degree level) that attract students from across the United Kingdom and abroad, the RCA and Central Saint Martins College of Art and Design, in particular, and several other London art-and-design schools as well, have become much-watched launching pads for British design's imaginative young innovators. After setting up their own studios and building up their portfolios, some of the designers featured in these pages, such as Morag Myerscough, Richard Bonner-Morgan, and Ben Tibbs, have written about or taught design, too. The same influential schools where they once studied now provide forums

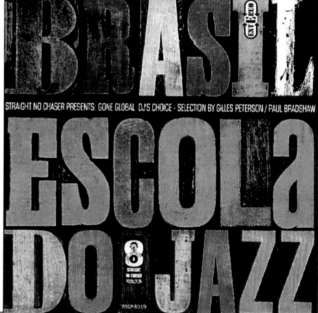

Jazz-album cover
ART DIRECTOR: Swifty
DESIGNER: Swifty

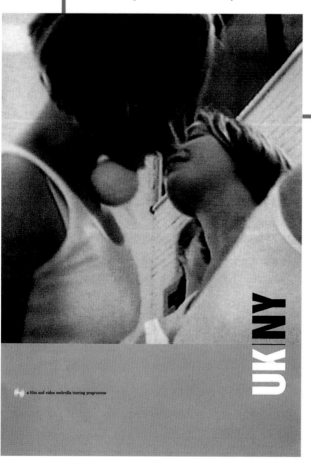

UK/NY *film and video program*
DESIGNER: Richard Bonner-Morgan

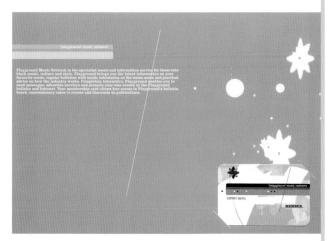

Playground Music Network
membership card
ART DIRECTION: Automatic
DESIGN: Automatic

Hayes and other informed observers also note, and even the first-time visitor will find it hard to miss, that an attention and responsiveness to design, a sensibility that experts refer to as "design literacy," is keenly present in contemporary Britain's general environment. It is nurtured, for instance, by the generations-old but still precisely effective signage and graphics of the London Underground. Or, to a designer's eyes, by such everyday treats as the Royal Mail's postage stamps and overall identity scheme or the simple, elegant packaging of the mid-market department-store chain Marks & Spencer's house brand of food products. Attractive, hard-working systems like these sensitize the public to the purposes and functional value of graphic design. They also help raise consciousness about what visual

in and from which these artist-thinkers can promulgate their theories, observations, aspirations, and critiques.

"Overall, the economy is good, and there is a lot of work for visual-communication specialists," according to Emily Hayes, a graphic designer by training and arts administrator who heads up the design-promotion division of the British Council, a government-supported organization that sponsors programs and exhibitions around the world about all forms of British culture. "Certainly, in graphic design, the computer is the dominant and most powerful tool, and there is something of a reigning techno look in a lot of music-related work and in ads or materials aimed at younger audiences. But a tremendous diversity of styles, approaches and philosophies is evident, too, and this is reflected in the many different kinds of design companies at work in London today."

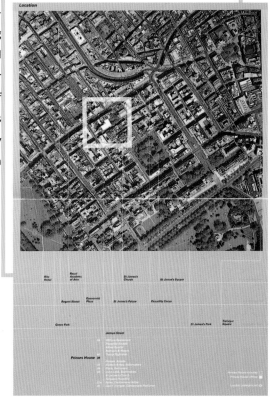

Prospectus booklet for
real-estate developer
ART DIRECTOR: Ian Cartlidge
DESIGNERS: Emma Webb,
Tim Beard, Ben Tibbs
PHOTOGRAPHER: Richard Learoyd
TECHNICAL ILLUSTRATOR: John Hewitt
COPYWRITER: Michael Horsham

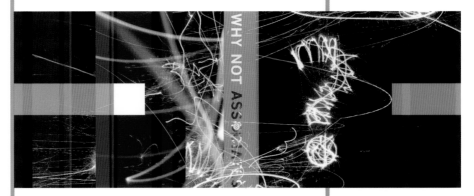

Why Not Associates book cover
DESIGNERS: Andrew Altmann, David Ellis, Patrick Morrissey, Iain Cadby, Mark Molloy, Jon Getz.
PHOTOGRAPHY: Rocco Redondo

communication, at its best, can and should be—and what it can and should do. (Ironically, notes award-winning Lewis Moberly designer Mary Lewis, a former president of British Design & Art Direction, "The downside of London's mature design culture is the cynicism of many clients.")

Depending on the nature of what British designers routinely call their "briefs" (the goals and standards that different problem-solving assignments should meet), a whiff of tradition and a sober tone, bold experimentation, or, inevitably, unabashed humor are some of the hallmarks of their work. Automatic's Martin Carty and Ben Tibbs tweak and update the familiar red-poppy symbol of the Royal British Legion's security service by rendering it as little more than two overlapping red squares. When not serving up startling visuals that grab the eye and shake up the senses—like a shot of a man's tongue poised perilously close to a hot clothes iron—the designers at Why Not Associates make posters or magazine layouts whose dramatic passages of abstract, ambiguous color or manipulated-photo imagery function as much as information

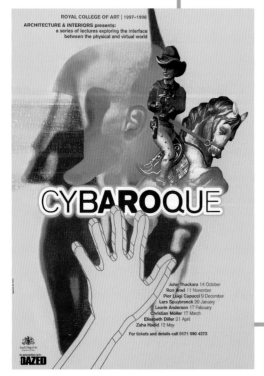

Poster for Royal College of Art
ART DIRECTION: Push
DESIGN: Push

RRRRRIDE THE TIGER

Think about human resources in a new way. Be imaginative in your thinking. Imagine a programme that encourages positive action, rewards new ideas, initiative, and drive. Imagine a practical programme to help you find new ways to get better results so you can drive yourself and the business forward. Imagine you're riding a tiger.

Graphics for human-resources materials for Novartis Consumer Health
DESIGN DIRECTORS: Mary Lewis, Martin Firrell
DESIGNERS: Bryan Clark, Ann Marshall

conveyors as they do as mood pieces. From the clever, visually or verbally punning work of such studios as Michael-Nash Associates or Johnson Banks, to Swifty Typografix's funked-up type and graphics that dance on the page, to the letterpress-inspired, illustrative typography of master type designer-printer Alan Kitching, among these communications artists, a little delight in the creative process goes a long way.

This is graphic design whose makers come to their work with varying degrees of attention to principles or lessons tried, true and, relatively speaking, old. But across the board, they come to it with irrepressible excitement about their ongoing adventure in a fast-evolving field. With this in mind, Martin Carty's and Ben Tibbs's tag lines on a set of promotional cards for their still-young studio may offer an apt description of the collective outlook many of the talents gathered here seem to share. With audacity and aplomb, they declare:

"Never shackled by the past. Not content with the present. Making room for the future."

A host of novel design ideas—some spontaneous and impulsive, some poetic or amusing, and still others studious and purposeful—take visible shape in the wide-ranging, pace-setting selections of works from the portfolios of the London-based designers that have been brought together here. To examine them is to savor, in a singular form, something of the remarkable energy and creative spirit that are part of their very special city's enduring allure.

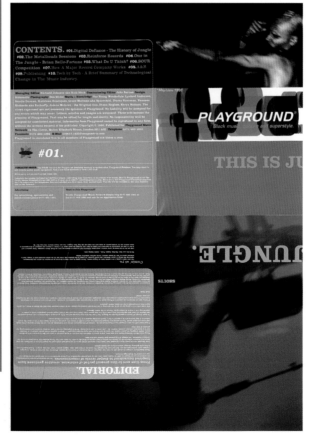

Playground Music Network magazine
ART DIRECTION: Automatic
DESIGN: Automatic

PRINCIPAL: Alan Aboud,
Sandro Sodano
FOUNDED: 1990

Studio 7
10-11 Archer Street
Soho
London W1V 7HG
TEL (44) 171-734-2760
FAX (44) 171-734-3551

Chance can be a formidable matchmaker. It decidedly helped determine the professional fate of Alan Aboud and Sandro Sodano. Both studied graphic design at Central Saint Martins College of Art and Design, but by their graduation in 1989, Sodano already had branched off into photography. When the two young designers were sharing studio space, Aboud needed a photographer when he landed work for fashion designer Paul Smith— and a creative team was born. Subsequently, through their extensive work for Smith's numerous lines, and for his R. Newbold subsidiary, through projects for book publishers and magazines, and through public-service campaigns, Aboud and Sodano became known for a look at once confident and understated. Photography figures prominently in their tightly art-directed compositions; typography is sparse and always precisely considered for its function and feel. "We seek a simple solution," notes Aboud, who comes from Ireland. "We don't want to confuse matters." The two designers often work together but may also pursue solo assignments. Sodano, who is from Wales, has his own photography career and has produced images for Calvin Klein, Hush Puppies, and other clients. Which partner takes the lead on an Aboud-Sodano project, Sodano says, "really depends on the client and on what's being discussed." Through their Paul Smith work, Aboud and Sodano have gained considerable experience in Japan, one of the label's major markets. Now represented by an American agent, the duo also has begun to work more often in the United States.

ABOUD-SODANO

In two series of advertisements for Paul Smith bags marked by the graphic designers' signature saturated color, Aboud and Sodano seem to merge an illustration-like treatment with photography that presents the featured products as fashion icons.
ART DIRECTOR: Alan Aboud
DESIGNER: Maxine Law
PHOTOGRAPHER: Sandro Sodano

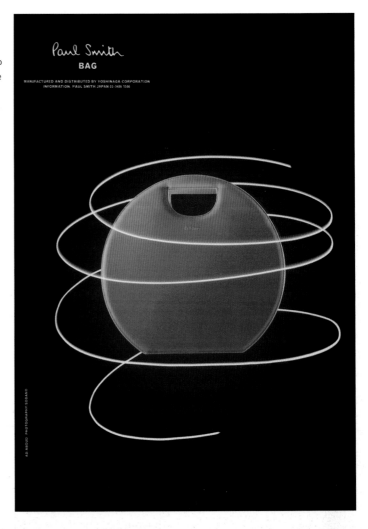

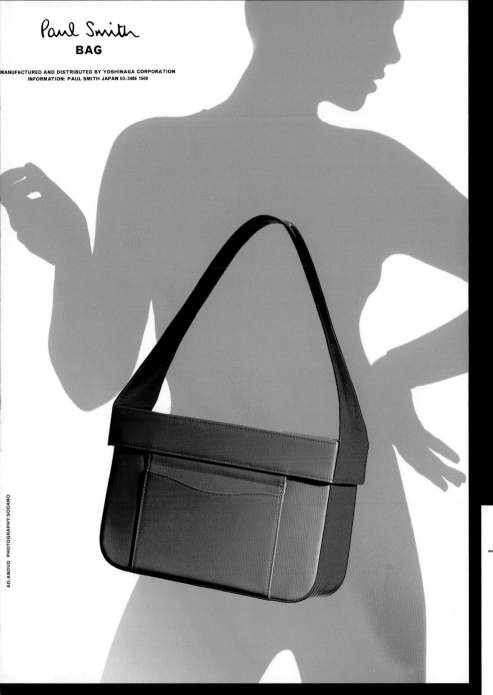

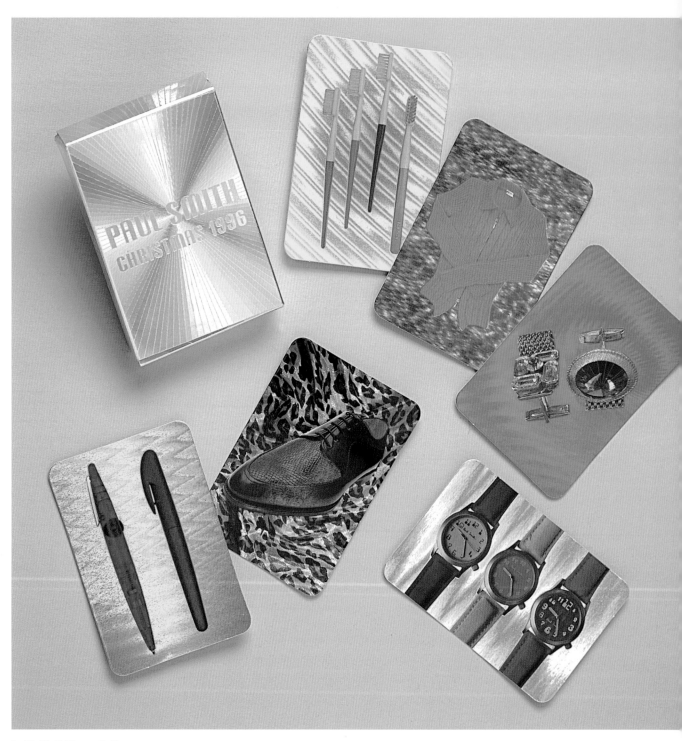

Paul Smith's Christmas 1996 gift
catalog was not a conventional
booklet or brochure at all.
Instead, Aboud-Sodano created
a deck of cards with photo images
of featured products printed
on luminescent, seemingly
holographic colored backgrounds.
ART DIRECTOR: Alan Aboud
DESIGNER: Maxine Law
PHOTOGRAPHER: Sandro Sodano

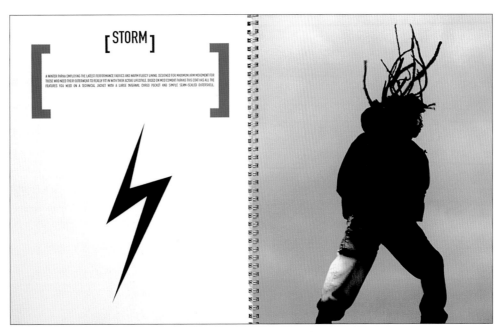

[STORM]

[A WINTER PARKA EMPLOYING THE LATEST PERFORMANCE FABRICS AND WARM FLEECY LINING. DESIGNED FOR MAXIMUM ARM MOVEMENT FOR THOSE WHO NEED THEIR OUTERWEAR TO REALLY FIT-IN WITH THEIR ACTIVE LIFESTYLE. BASED ON MOD COMBAT PARKAS THIS COAT HAS ALL THE FEATURES YOU NEED ON A TECHNICAL JACKET WITH A LARGE INTERNAL CARGO POCKET AND SIMPLE SEAM-SEALED OUTERSHELL]

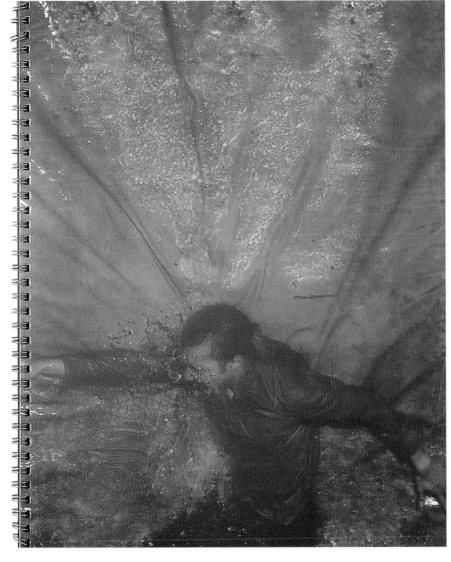

For an R. Newbold collection of autumn-winter clothes whose theme was *storm*, Aboud-Sodano created a waterproof promotional booklet. The spiral-bound publication's covers are made of PVC, and its pages are plasticized. The unusual fashion images inside, Aboud says, emphasize the "extreme nature of the weather" in which the clothes are meant to be worn.

ART DIRECTOR: Alan Aboud
DESIGNER: Alan Aboud
TYPOGRAPHER: Alan Aboud
PHOTOGRAPHER: Sandro Sodano

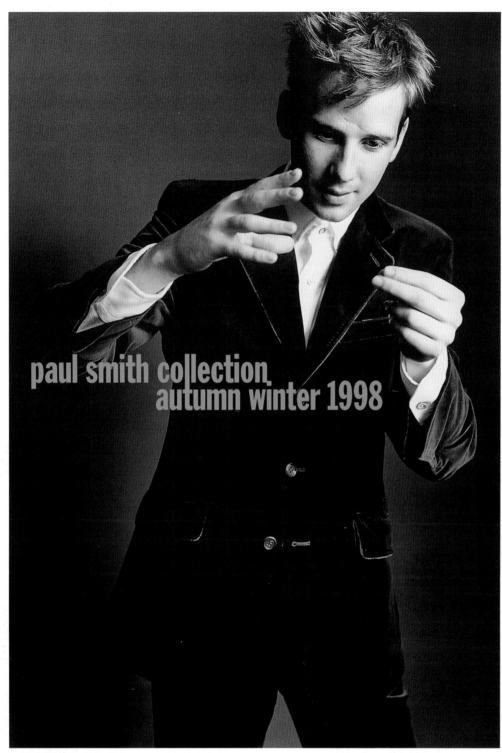

paul smith collection
autumn winter 1998

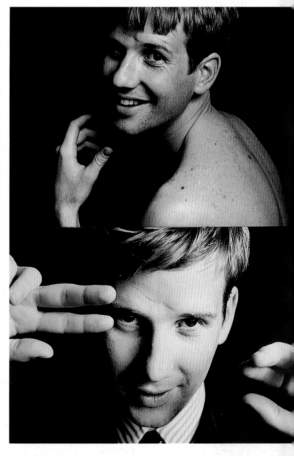

A large-format promotional booklet for Paul Smith, printed on thick, glossy cover stock, contains a smaller staple-bound booklet inside.

ART DIRECTOR: Alan Aboud
DESIGNER: Maxine Law
PHOTOGRAPHER: Mario Testino

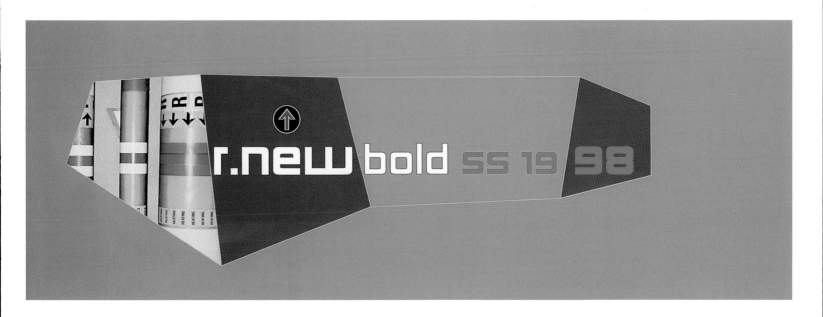

As art director, Alan Aboud
used an uncommonly long,
horizontal format for a full-color
promotional booklet for the

PRINCIPALS: Jayne Alexander, Violetta Boxill

FOUNDED: 1994

Studio 53
Pennybank Chambers
33-35 St. John's Square
London EC1M 4DS
TEL (44) 171-251-5256
FAX (44) 171-251-5256

In London, Jayne Alexander, originally from Wales, studied at Central Saint Martins College of Art and Design, and Violetta Boxill, from the north of the city, attended Middlesex University. Later, they met during the renowned, two-year master's-degree program in graphic design at the Royal College of Art. Although they deeply respected each other's work, Alexander and Boxill did not join creative forces until after graduation, when they landed a big account, including a total corporate-identity scheme for Greig Fester, a reinsurance company, that set them up in business in one stroke. "They were completely open to our ideas," Boxill recalls, "which was unusual for such a large company, and especially for us, as a new, unknown studio." In a short time, though, from their small, fastidiously tidy office in London's Clerkenwell district, Alexander and Boxill have made a distinct and recognizable mark. Their work follows no formulas and has avoided a strict house look. As in many of London's smaller studios, Alexander and Boxill often shoot their own photography, create their own typography and micromanage every project right through the pre-press stage. Such meticulousness shows in the high production quality and in the concentrated energy that their posters, brochures and publication design exude. In their compositions, which can border on the abstract, they sometimes fragment type elements or the two-dimensional text-and-image plane itself. Often, for impact, they use a limited palette instead of full color.

ALEXANDER BOXILL
VISUAL COMMUNICATION

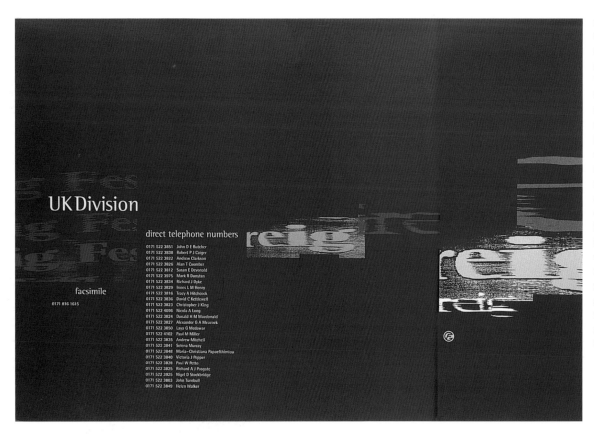

Overhauling reinsurance company Greig Fester's corporate identity was the new Alexander Boxill studio's first big assignment. The designers used abstracted, fragmented type in an illustrative treatment of the company's reworked logo. They also used a limited but powerful palette of dark, purplish blue, orange, white, and silver to give its printed materials a combined authoritative and elegant look. Their overall design breaks the mold of the familiar, stuffy graphics found in the management and financial sectors; it also alludes to innovation and the speedy transmission of data.

ART DIRECTORS: Jayne Alexander, Violetta Boxill

DESIGNERS: Jayne Alexander, Violetta Boxill

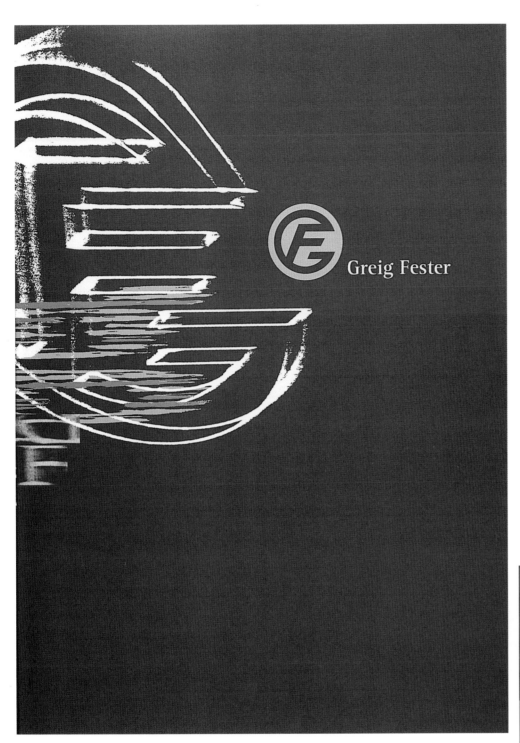

Greig Fester

GAP takes a unique, original and totally innovative approach. It comprises a variety of ideas and analytical techniques from different sources to create our own models developed specifically for the UK.

Alexander Boxill produced this
poster explaining color
separations as an educational
tool for foundation students in
art and design programs.
ART DIRECTORS: Jayne Alexander,
Violetta Boxill
DESIGNERS: Jayne Alexander,
Violetta Boxill

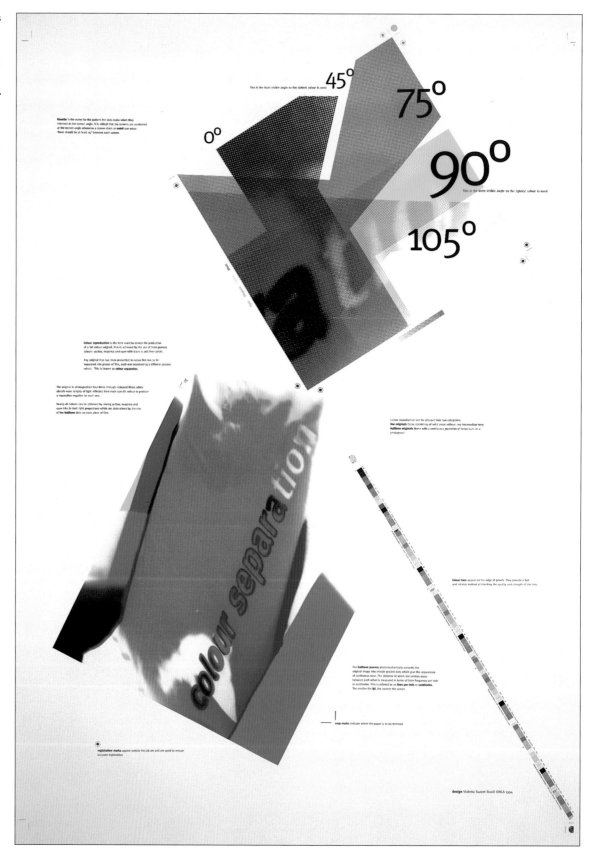

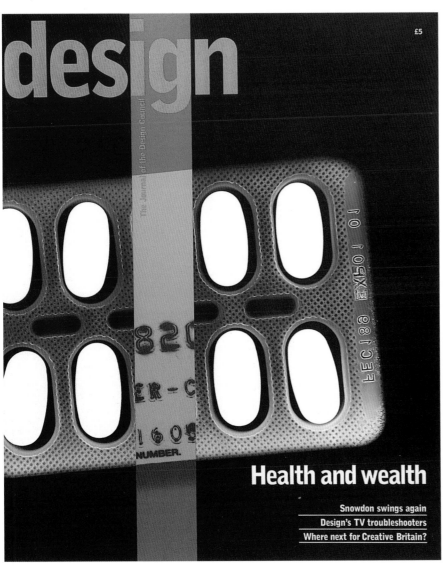

Health and wealth

Snowdon swings again
Design's TV troubleshooters
Where next for Creative Britain?

Alexander Boxill recently took
over the art direction of *Design*,
the magazine of Britain's
influential Design Council.
ART DIRECTORS: Jayne Alexander,
Violetta Boxill
DESIGNERS: Jayne Alexander,
Violetta Boxill

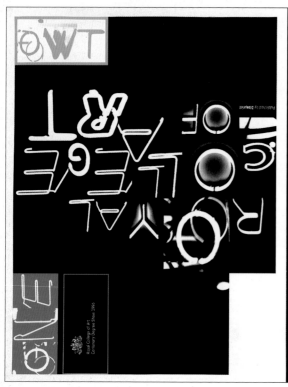

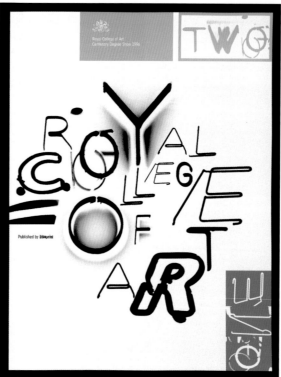

Alexander and Boxill created
their own typeface, called 100
Watt, which is based on neon
letterforms that they photographed
all around London. They used it
in posters, admission cards, and
related materials for the 1996
Centenary Degree Show at the
Royal College of Art. The designers
produced both solid and outline
versions of their original typeface.
ART DIRECTORS: Jayne Alexander,
Violetta Boxill
DESIGNERS: Jayne Alexander,
Violetta Boxill

Inside Alexander Boxill's folder
for promotional materials for
Yellow Diva, a furniture company,
a die-cut pocket replicates the
shape of some of the firm's curvy
furnishings.
ART DIRECTORS: Jayne Alexander,
Violetta Boxill
DESIGNERS: Jayne Alexander,
Violetta Boxill

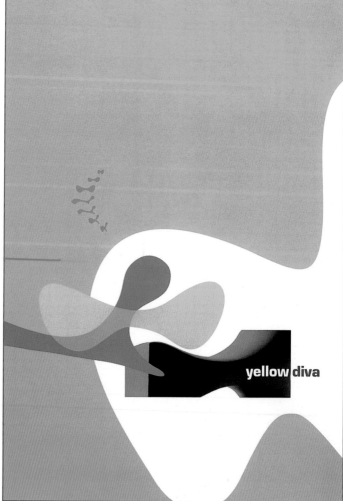

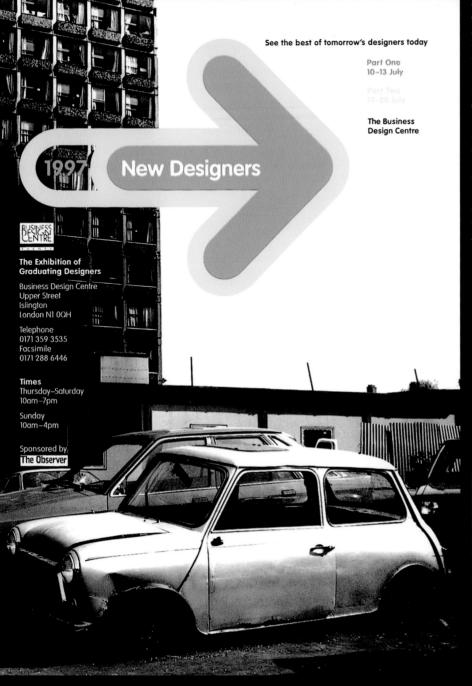

See the best of tomorrow's designers today

Part One
10–13 July

Part Two
17–20 July

**The Business
Design Centre**

1997 New Designers

**The Exhibition of
Graduating Designers**

Business Design Centre
Upper Street
Islington
London N1 0QH

Telephone
0171 359 3535
Facsimile
0171 288 6446

Times
Thursday–Saturday
10am–7pm

Sunday
10am–4pm

Sponsored by
The Observer

Alexander and Boxill created a
complete visual-identity scheme
and collection of printed materials
for the Business Design Centre's
"New Designers" program and
show. The bold and simple arrow
logo suggests progress and a
dynamic energy. Often they
placed it against their own black-
and-white photos of old, found
objects, including autos and
shopping carts. In this work,
typically, the designers create a
look with memorable impact out
of a few basic, uncomplicated
elements.

ART DIRECTORS: Jayne Alexander,
Violetta Boxill
DESIGNERS: Jayne Alexander,
Violetta Boxill

Alexander Boxill's self-promotional postcards use some of the designers' favorite colors, including hot pink and silver.
ART DIRECTORS: Jayne Alexander, Violetta Boxill
DESIGNERS: Jayne Alexander, Violetta Boxill

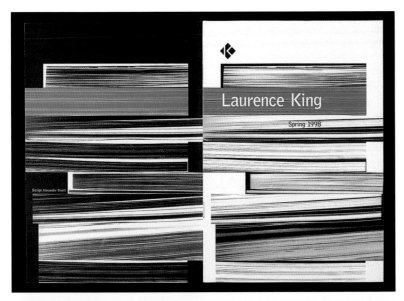

Photo images of beautifully abstracted stacks of books are the central motifs in Alexander Boxill's designs of catalogs for the British publisher Laurence King.
ART DIRECTORS: Jayne Alexander, Violetta Boxill
DESIGNERS: Jayne Alexander, Violetta Boxill

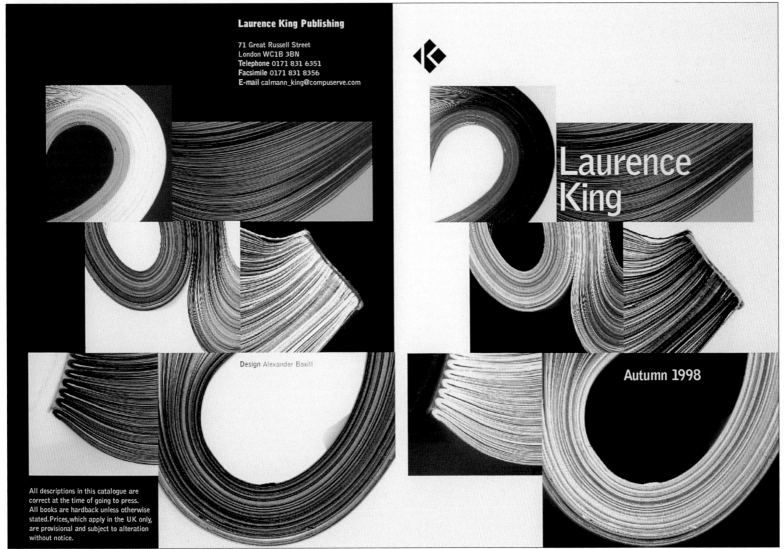

PRINCIPALS: Martin Carty,
Ben Tibbs
FOUNDED: 1995

Floor 2
1 Tysoe Street
London EC1R 4SA
TEL (44) 171-278-2070
FAX (44) 171-278-2070

Like a number of notable young image-makers and visual-communication specialists in London today, Automatic's Martin Carty and Ben Tibbs earned degrees in the post-graduate graphic-design program at the Royal College of Art (RCA). Tibbs has been particularly interested in the theoretical and practical issues affecting the increasingly malleable and manipulated photo image in these postmodern times; photography is "so real . . . it's unreal," he wrote in an essay-booklet that he designed and published while still at the RCA. Automatic's work, like that of other compact studios, stretches the expressive capacities of the limited color palettes and less costly production methods that are common in smaller print jobs. To achieve more with less, Carty and Tibbs will not shy away from using a bright, neon-orange in a poster's big display-type headline, nor will they hesitate to mix up typefaces, as they do in graphics for Playground Music Network. In these ways, they create varied visual textures and remarkably rhythmic compositions in layouts that are sometimes as small as business cards (as in their music-promo stickers). For Tactical, a London café-bar, Automatic conjured up Konstrukt, a typeface whose blocky letterforms march vigorously across this new food-and-culture venue's windows and the printed materials that Carty and Tibbs produced to promote it. They can flex their muscles in a more conservative corporate mode, too, as in their recruitment pamphlet for the Royal British Legion's security service. Here, with quiet ingenuity, their revamped logo for the organization evokes its traditional poppy symbol with little more than two overlapping, round-cornered red squares.

AUTOMATIC

Bright, neon-orange headlines pop out of this poster that announces art and design programs at Kingston University, in Surrey.
ART DIRECTION: Automatic
DESIGN: Automatic

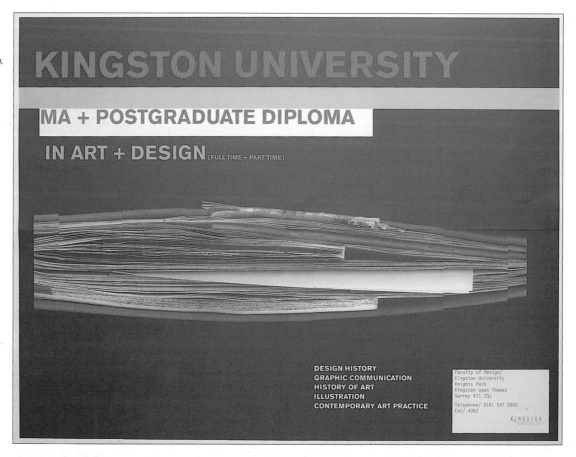

Building on our past, to protect your future

Royal British Legion Security is the security division of the Royal British Legion Attendants Co Ltd. For over 70 years the company, which was founded as a registered charity to find honourable work for ex-HM services personnel of impeccable character, has specialised in providing a comprehensive range of guarding services at the blue-chip end of the market for both the public and private sectors.

Our personnel bring to their duties all the very best qualities of TODAY'S armed forces. These are men and women who have served in Northern Ireland, the Gulf, Falklands, and Bosnia. Smartness, integrity, good humour and plain common sense are our hallmarks. Motivation and loyalty are our watchwords.

Our success over the years has relied upon a number of core values:

- The use of high calibre and highly motivated ex-service personnel.
- Thorough vetting, recruitment and training of personnel to the highest BSIA standards and beyond.
- A high management ratio with comprehensive control, back-up, welfare and supervision, allowing for an extraordinary depth of support to our security teams.
- A decently rewarded and well motivated work force, possessed of enormous loyalty and commitment.
- Partnership with our clients through consistency in performance, close liaison at all levels of management and flexible response to their changing needs.

Security Services/

Professional Service Capacity
Specialists in the provision of high calibre Royal British Legion trained and managed security personnel for:

Static Duties
- Government, Commercial & Industrial facilities, Shopping Malls and the retail sector.
- Providing an invaluable service to the widest range of clients and locations.
- Access Control, security tracking and constant foot patrols to minimise risk.

CCTV Monitoring
RBLS may now be regarded as the leaders in the provision of highly trained, professional CCTV personnel, working to approved standards of evidence handling and control room procedure.

Commissionaires
Selected and trained to be diplomatic, efficient enhancing your company image whilst maintaining high levels of security.

Mobile Patrols
High-profile, electronically recorded patrols in RBLS liveried vehicles are a cost effective means of security by providing random timed and recorded inspection of your premises when continuous attendance of Security Officers cannot be justified.

Key Holding and Alarm Response
Services to strict BSIA guidelines.

Security Receptionists
Security trained, uniformed or non-uniformed reception staff.

Aviation/

- Single source integrated Aviation Security Services.
- Recognised and approved by DETR and governmental agencies.
- From perimeter to R-Z - from baggage to aircraft clean and search.
- Employing First Class, CTC Vetted Ex-military personnel, trained to the highest AMSA standards, operating in line with the National Aviation Security Programme.

Car Park Management/

On-Street Parking Enforcement and Control
PCN/ECN ticket issue, cash collection, residents parking and permit issue and control.

Off-Street Parking Enforcement and Control
Professional management of all parking facilities, including Airports, multi-story, surface, hotel, hospitals, railways and leisure.

CCTV Monitoring
Provision of highly trained personnel, working to approved standards of evidence handling and control room procedure.

Decriminalisation Parking Enforcement
Including car compound management, uniformed parking attendants and notice processing and issue.

Cash Collection, Banking and Audit Control
Carried out to strict BSIA standards; high and low profile secured vehicles and personnel.

Traffic Management Information
Traffic-Flow Revision
AA Gold Award Specialist

Royal British Legion
Security

British Security Services and
Car Park Management

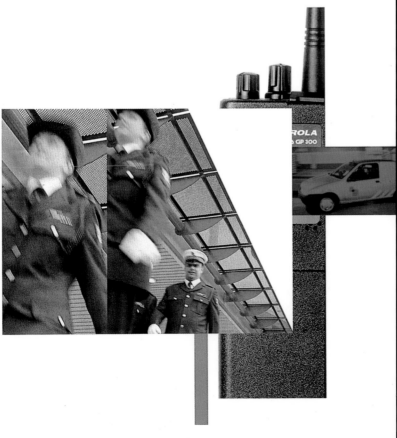

Black, red, and silver inks on white card stock are the simple ingredients of Automatic's recruitment pamphlet for the security services of the Royal British Legion. Carefully chosen and cropped photos evoke a sense of a workday in the life of a services member; abstracting the organization's traditional poppy symbol, Carty and Tibbs revise it in the form of two overlapping red squares.

ART DIRECTION: Automatic

DESIGN: Automatic

REPORTAGE PHOTOGRAPHY:
Rob Decelis

LONDON
AGENDA
1997 European year
against racism

ENTERPRISE FOCUS 1997

opportunity

celebrating diversity

THE PREMIER BUSINESS EXHIBITION, CONFERENCE AND SEMINARS IN EUROPE FOR REACHING ASIAN, AFRICAN AND CARIBBEAN MARKETS

Barbican Centre, London, UK. 26 - 28 June 1997

● EQUATOR INTERNATIONAL

Simple geometric shapes animate the design, marked by a limited color palette, of a pamphlet that announces an exhibition and conference that focus on business themes.

ART DIRECTION: Automatic
DESIGN: Automatic

Automatic created a full range of colorful graphics for Playground Music Network, a kind of information-services club with its own Web site for fans of black music, culture, and style. The service also publishes a magazine. Shown here: the service's stationery, membership card, and promotional stickers.

ART DIRECTION: Automatic

DESIGN: Automatic

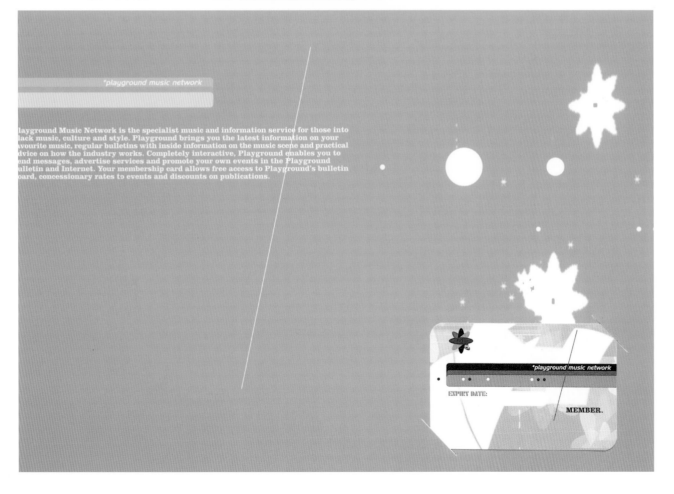

Playground Music Network is the specialist music and information service for those into black music, culture and style. Playground brings you the latest information on your favourite music, regular bulletins with inside information on the music scene and practical advice on how the industry works. Completely interactive, Playground enables you to send messages, advertise services and promote your own events in the Playground bulletin and Internet. Your membership card allows free access to Playground's bulletin board, concessionary rates to events and discounts on publications.

Automatic designed a magazine for Playground Music Network in the form of a poster that unfolds to reveal "pages" of varying sizes. Both sides of a large, semi-glossy broadsheet are printed to make the publication.

ART DIRECTION: Automatic

DESIGN: Automatic

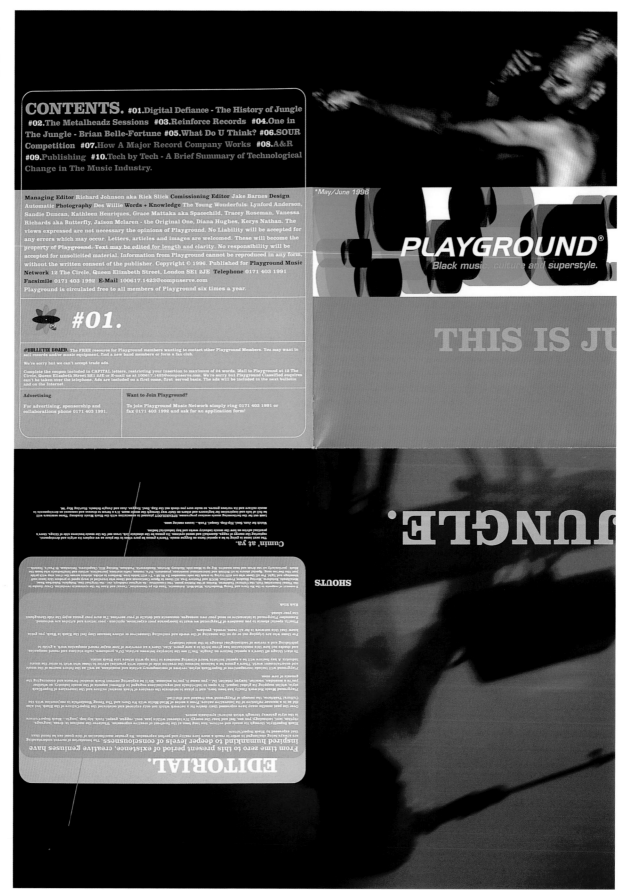

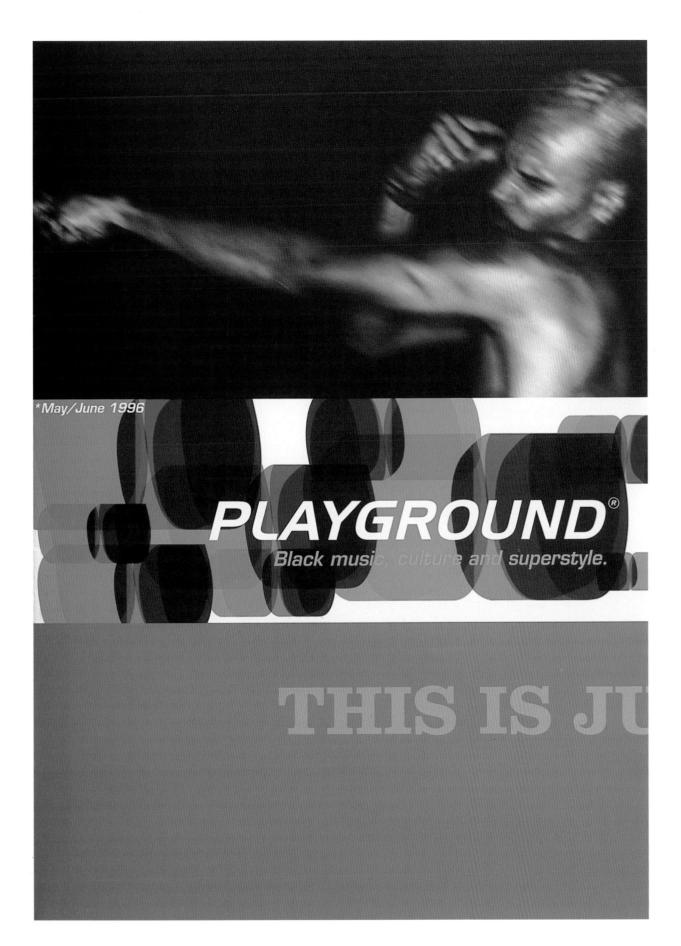

*May/June 1996

PLAYGROUND®

Black music, culture and superstyle.

THIS IS JU

Carty and Tibbs like to experiment
with printing techniques in the
service of imaginative design. For
the launch of Tactical, a London
café-bar featuring art and music
events, they produced a poster
printed on both sides which,
when cut up into page-sized units
and staple-bound, yielded a kind
of multi-dimensional promotional
booklet for the new venue.
Depending on how the trimmed
and bound pages fall in the
booklet, the orientation of each
page may vary. The designers
also made promotional postcards.

ART DIRECTION: Automatic

DESIGN: Automatic

LOCATION PHOTOGRAPHER:

Louie Quayle

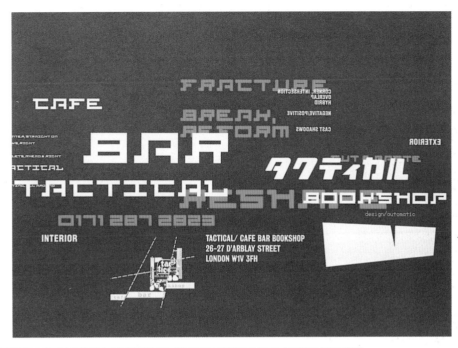

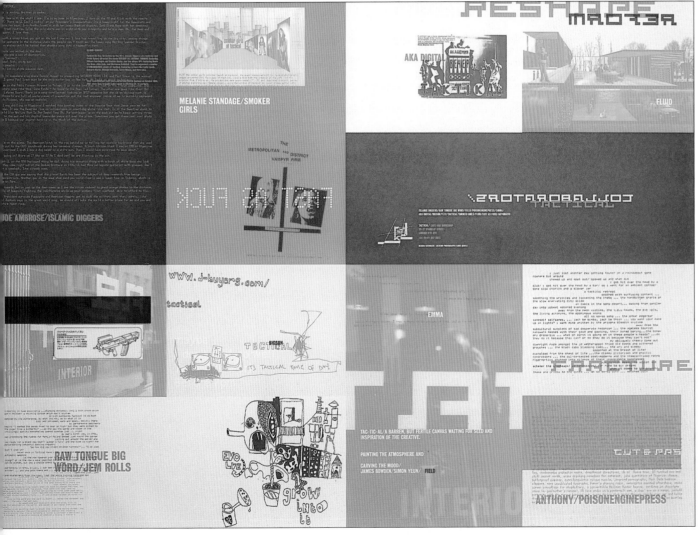

PRINCIPALS: Ian Cartlidge,
Adam Levene
FOUNDED: 1987
NUMBER OF EMPLOYEES: 5

238 St. John Street
London EC1V 4PH
TEL (44) 171-251-6608
FAX (44) 171-253-0804

Cool, crisp, clean, and eloquent, Cartlidge Levene's design of prospectus booklets and other materials for some of the impressive renovation projects that are rejuvenating London's historic riverfront do as much to help sell these properties as they do to define them as new places and products in the real-estate market. Founders Ian Cartlidge and Adam Levene and their collaborators pride themselves on being "highly experienced at project management," a skill that shows in the firm's carefully conceived and meticulously executed brochures, annual reports, catalogs, corporate-identity schemes, signage systems, and exhibition designs for such clients as the Royal Institute of British Architects, the Society for Typographic Design, and the British government's Department of the Environment, Transport and the Regions. Cartlidge Levene's use of photography can be both documentary and inspiring; for example, its booklet for a renovated warehouse on Regent's Canal is divided into two sections, one full of Richard Learoyd's evocative images of the surrounding neighborhood's sights and textures, and another full of diagram-supported hard data about loft-purchase options and other specifications. Cartlidge Levene often builds flexibility into its design solutions; the simple elements of its layouts for The Earth Centre's promo booklet, for instance, can easily, effectively be transposed to billboard scale. An ability to boil down, visually and verbally, expansive concepts or detail-heavy information to an essential message expressed concisely in graphic-design terms gives this studio's work its strong impact. It strives to draw viewers in, the designers say, "and engage them on an emotional as well as an intellectual level."

CARTLIDGE LEVENE

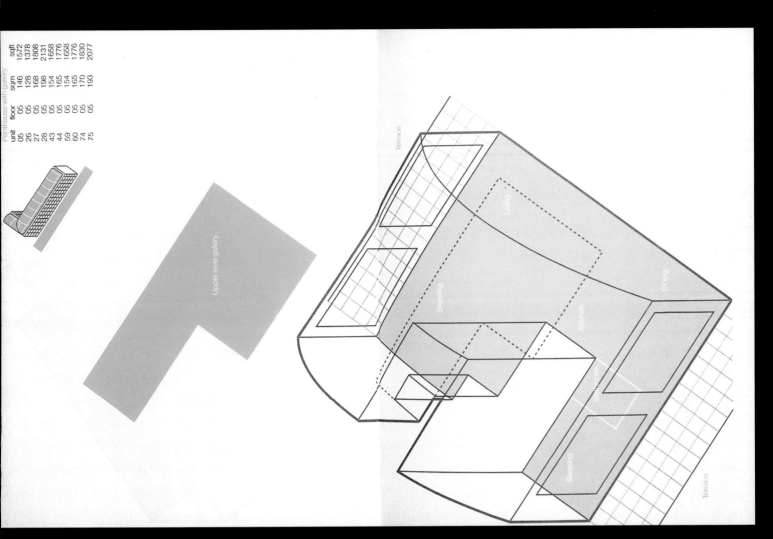

A perfect-bound prospectus for
Millennium Lofts in the Canal
Building, a renovated
warehouse on London's river-
front, consists of a photo-filled,
scene-setting section followed
by another full of diagrams and
hard data about the property.
ART DIRECTOR: Ian Cartlidge
DESIGNERS: Ian Styles,
Emma Webb, Hugh Tarpey,
Phil Costin
PHOTOGRAPHER: Richard Learoyd
TECHNICAL ILLUSTRATOR:
John Hewitt

Cartlidge Levene's design of issue 51 of *TypoGraphic*, the journal of the International Society of Typographic Designers, features faint to dark shades of blue type set against generous expanses of white, or dropped-out white type against blue, and Richard Learoyd's sparse photography, run illustratively or run small, in a concentrated serving of high-concept text and visuals.

ART DIRECTOR: Ian Cartlidge
DESIGNERS: Ian Styles, Hugh Tarpey, Emma Webb, Phil Costin

exhilarate
inspire
engage
empower
educate

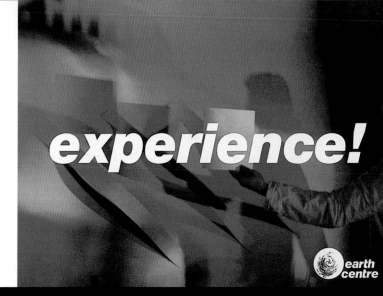

experience!

think!
experience!
act!

For The Earth Centre, a
Millennium Commission project
in Doncaster that will promote
the understanding of sustainable
development, Cartlidge Levene
designed a brochure aimed at
potential professional partners. It
is divided into sections entitled
simply "Think!" "Experience!"
and "Act!" The designers' stated
goal: "to engage readers on
an emotional as well as an
intellectual level."
ART DIRECTOR: Ian Cartlidge
DESIGNERS: Emma Webb, Hugh
Tarpey, Ian Styles, Phil Costin
PHOTOGRAPHER: Peter
Marlow/Magnum Photos

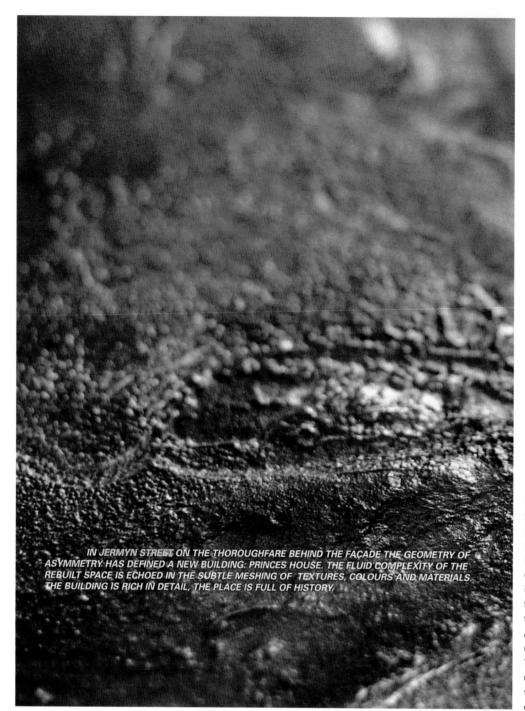

IN JERMYN STREET ON THE THOROUGHFARE BEHIND THE FAÇADE THE GEOMETRY OF ASYMMETRY HAS DEFINED A NEW BUILDING: PRINCES HOUSE. THE FLUID COMPLEXITY OF THE REBUILT SPACE IS ECHOED IN THE SUBTLE MESHING OF TEXTURES, COLOURS AND MATERIALS. THE BUILDING IS RICH IN DETAIL, THE PLACE IS FULL OF HISTORY.

This perfect-bound prospectus for a renovated historic building, Princes House, from Ivory Gate, Ltd., demonstrates Cartlidge Levene's penchant for boiling down the essence of an information-rich message and finding concise, powerful ways to give it visual, tangible form.

ART DIRECTOR: Ian Cartlidge
DESIGNERS: Emma Webb, Tim Beard, Ben Tibbs
PHOTOGRAPHER: Richard Learoyd
TECHNICAL ILLUSTRATOR: John Hewitt
COPYWRITER: Michael Horsham

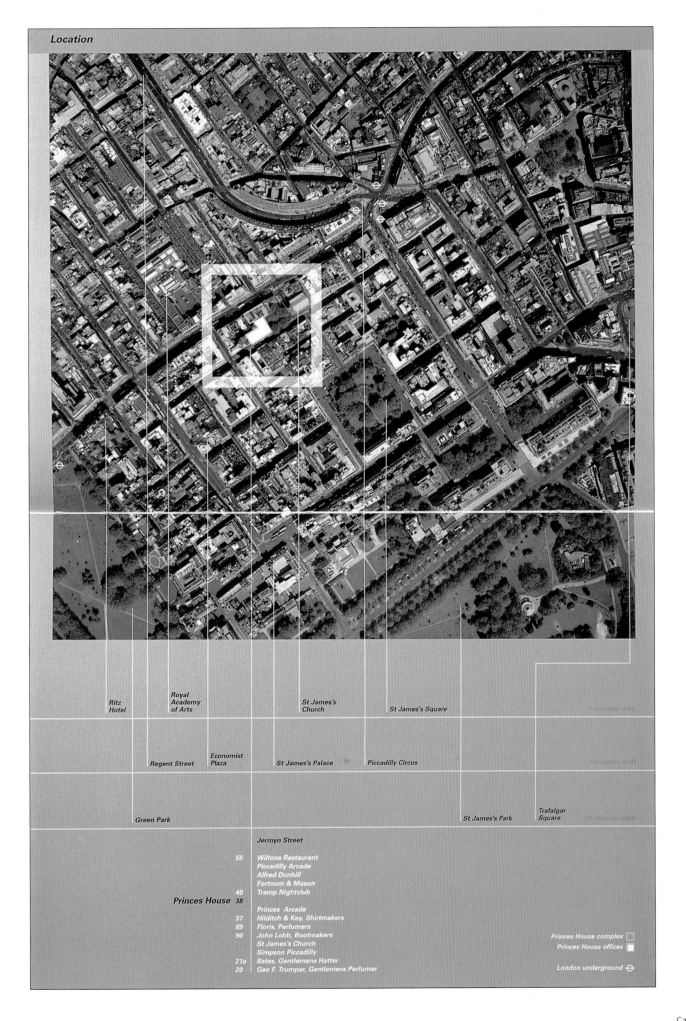

Ritz
Hotel

Royal
Academy
of Arts

St James's
Church

St James's Square

Regent Street

Economist
Plaza

St James's Palace

Piccadilly Circus

Green Park

St James's Park

Trafalgar
Square

Jermyn Street

55 Wiltons Restaurant
Piccadilly Arcade
Alfred Dunhill
Fortnum & Mason
40 Tramp Nightclub

Princes House 38

Princes Arcade
37 Hilditch & Key, Shirtmakers
89 Floris, Perfumers
90 John Lobb, Bootmakers
St James's Church
Simpson Piccadilly
21a Bates, Gentlemens Hatter
20 Geo F. Trumper, Gentlemens Perfumer

Princes House complex ☐
Princes House offices ◼

London underground ⊖

PRINCIPALS: Mike Dempsey,
Nick Thirkell, Iain Crockart,
Ashwin Raithatha, Ian
Chilvers, Neil Walker
FOUNDED: 1979
NUMBER OF EMPLOYEES: 14

21 Brownlow Mews
London WC1N 2LA
TEL (44) 171-242-0992
FAX (44) 171-242-1174

Judging from the scope, quality, and consistently sharp looks of projects in CDT's extensive portfolio, a viewer may quickly assume that this studio, one of the best-known and most respected on the British design scene, is correspondingly huge. In fact, CDT is a medium-size design consultancy, as such companies are called in the United Kingdom, and its members plan to keep it that way. "Size counts for nothing in graphic design," a CDT statement declares. "It has been our policy to stay small even during the design boom because we believe strongly that [our] directors, as designers themselves, should be involved in every project." Over the years, that close association between CDT's senior designers and their clients has nurtured their expertise in developing corporate-identity programs in all of their increasing versatility and complexity. Among those programs: slick, pop-flavored logos and related commercial schemes that employ them, like CDT's bright red,

coordinated graphics-and-interiors system for Our Price, a chain of music stores; and more stately, elegant logo-and-signage programs for cultural institutions such as the Royal National Theatre and the English National Opera. Fittingly, CDT has created graphics for the Design Council and for the Design Museum in London; recently, too, principal Mike Dempsey served as president of British Design & Art Direction (D&AD), a leading professional organization in the fields of advertising and visual communication. Known for staying fresh and innovative in a highly competitive field, CDT has routinely scooped up some of British design's most prestigious awards, including D&AD Gold and Silver Pencils.

CDT DESIGN, LTD.

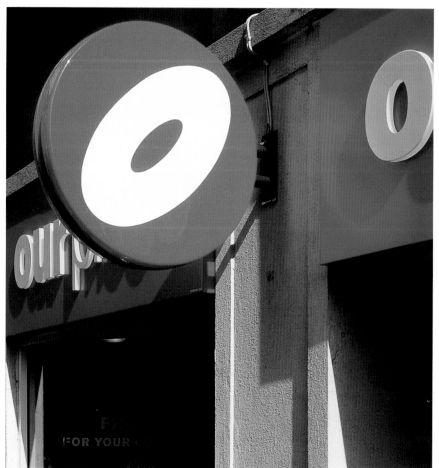

CDT created a bold visual-identity and retail-interiors scheme for Our Price, a chain of music stores, using a powerful palette of red, white, and black. Energy oozes from the off-kilter *O* in the company's simple logo; and the overall character of the graphic design, in posters and signage is crisp and alive.

BRAND RELAUNCH AND IN-STORE SIGNAGE: Iain Crockart
CREATIVE DIRECTOR: Nick Thirkell
DESIGNER: Iain Crockart

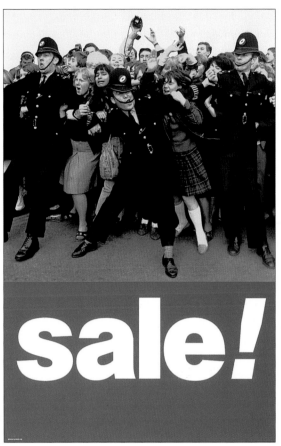

"Sale!" poster
CREATIVE DIRECTOR: Iain Crockart
DESIGNER: Andy Mosley

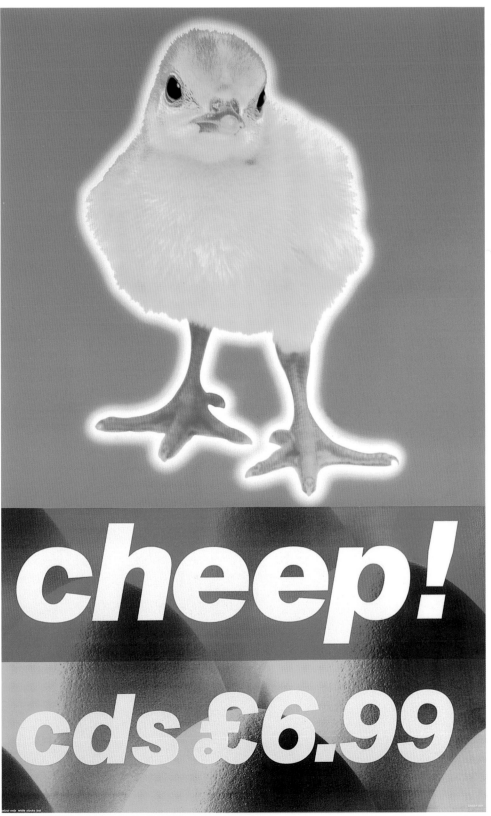

"Cheep!" poster
CREATIVE DIRECTOR: Iain Crockart
DESIGNER: Andy Mosley
PHOTOGRAPHER: Paul Zak

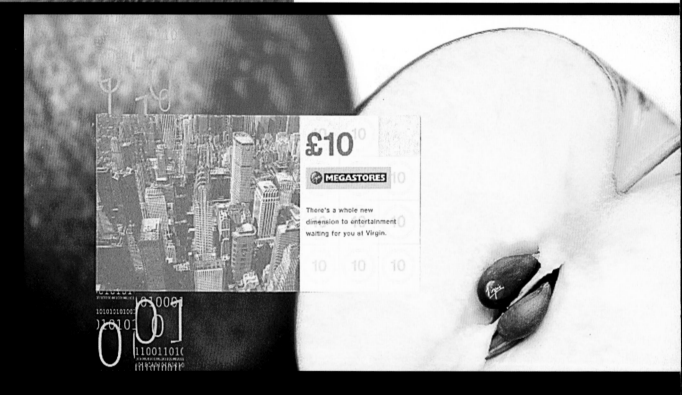

Gift Vouchers from Virgin Megastores
Use them to show your appreciation to staff and customers and
be sure of staying on their wavelength.

£10

MEGASTORES

There's a whole new
dimension to entertainment
waiting for you at Virgin.

10 10 10

Color photography that hints at rich visual textures is a key element in the small, horizontal-format pages of a brochure to promote gift vouchers from Virgin Megastores.

CREATIVE DIRECTOR: Iain Crockart
DESIGNER: Simon Elliott
VOUCHERS, CREATIVE DIRECTOR AND DESIGNER: Iain Crockart

Our discount rates are highly competitive:

£501 – £999 = 2.5% £1000 – £9999 = 5% £10,000 – £50,000 = 7.5% £50,000 or more = negotiable

We can provide a range of denominations, £1, £5, £10 and £20.
Vouchers can be redeemed at any Virgin Megastore, as well as all Our Price stores and branches of WHSmith.

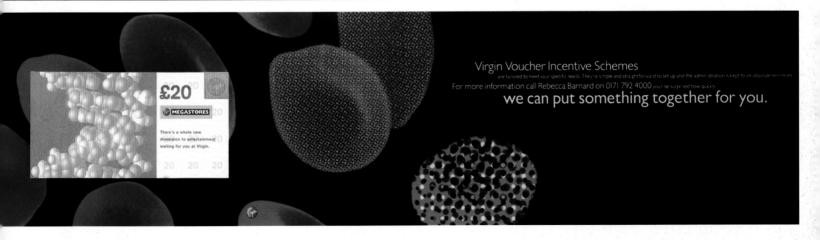

Virgin Voucher Incentive Schemes are tailored to meet your specific needs. They're simple and straightforward to set up and the administration is kept to an absolute minimum. For more information call Rebecca Barnard on 0171 792 4000 you'll be surprised how quickly we can put something together for you.

Design correctly harnessed can enhance life, create jobs and make people happy - not such a bad thing. Paul Smith Good design looks good, works well, cuts costs. Lord Strathcylde I believe design is intention, purpose, plan: and that good design is therefore by inference, where such plan has been well conceived, well executed, and of benefit to someone. Milner Gray Less is more - providing you had more to begin with. Rodney Kinsman The Government is convinced that design is fundamental to winning in the world market. Good design is a crucial part of competitiveness. Rt Hon John Major MP Excellence in design is fundamental to engineering success. Sir William Barlow As a practising doctor, design impinges on my work in two ways: good technological design makes things easier to use; good aesthetic design makes them pleasing to use. Technology without aesthetics is like nutrition without the taste, smell and visual appeal of food. Dr Rhys Hamilton Design unlocks innovation and turns ideas into reality. John Sorrell The difference between good design and bad design is simply a little thought. Sir Neil Cossons Design: The creative harmonic between culture and industry, technology and consumers, and engineering and art. Dick Powell The point about good design is that it imposes order and simplicity on a chaotic world. It makes it easier to think. Prue Leith Design adds the extra dimension to any product - added sales, added profitability but above all added and lasting pleasure to those who buy it, those that make it and those that behold it. Sir John Harvey-Jones Outstandingly good design in non-manufacturing, service industries is not an optional extra. It is an essential part of everything a company does and what it stands for. It can make the difference between success and failure. Richard Dykes To design is to predict and to prophesy, and is the constructive application of knowledge to that which we make. Sir Philip Dowson Design is a provider of pleasure: Pleasure for the user. Pleasure for the maker. Pleasure for the designer. The artefact decides how this pleasure is divided. Kenneth Grange Design is the exercise of mixing key elements to create a new solution to a task - good designs are those which appeal through not only solving the task but also stir the emotions through elegance, style or wit. Barrie Weaver With art - if you like, you can be really weird. But in design you have to think about what other people will like. Ghisli, aged 10 Design is distinctive eye-appealing shape or pattern adding value to daily routines. Paul Gavin Design is about increasing competitiveness, enhancing quality of life, and changing perceptions. That's why it's so important to get it right. Christopher Wade Design is the tribute Art plays to Industry. Paul Finch Design is all around us - either we control it - or it controls us. Wally Olins Design is an intuitive and iterative process which combines the harmony of form, the demands of technology and scientific reason - at the same time as yielding to the laws of economics. Jane Priestman Design is the tool that can change an invention into an innovation, transforming an idea into a successful product for the world market. Paul Ambridge Today, design is like the Arab term al-sirat - a bridge to heaven. Unfortunately this bridge is only the width of the edge of the sword. William Alsop Designers are the blue collar workers of the Art world. Alan Fletcher Good design is not simply about aesthetics or making a product easier to use. It is a central part of the business process, adding value to products and creating new markets. Rt Hon Tony Blair MP Design is thinking. Anyone who can think well can design well. Quentin Newark Design is maximising fitness for purpose and aesthetics profitability. It is not an after-thought, it is integral to the successful commercialisation of technological and business innovation. David Grayson Design helps us to think about problems and solve them with our own ideas. Michael, aged 10 The design process has an over-whelming effect on the efficiency and profitability of a manufacturing company, controlling about 85% of the costs and defining almost 100% of the added value which can be obtained from the sale of a product. Ivan Yates Design is a skillful process which creates value and competitiveness in a product through its form, its function and its financial effectiveness. Good design often relate to one or two of these attributes - great designs relate to them all. John Towers Design is the difference between doing it, and doing it right. Mark Fisher MP Design is 98% commonsense and 2% that magic ingredient sometimes called aesthetics and sometimes style. Sir Terence Conran

Design Council

Sharp color photography and clear, uncluttered layouts distinguish CDT's annual report for Britain's Design Council
CREATIVE DIRECTOR: Ian Chilvers
DESIGNERS: Ian Chilvers, Andrew Slatter
PHOTOGRAPHERS: Justin Quick, Edmund Clark

John Sorrell

These are exciting times for the Design Council. The climate for design in Britain is improving and a real shift in attitudes is taking place. The imminence of the millennium has become a catalyst for fresh ideas. Business people and educators are becoming more aware of the difference design could make to our economy and our quality of life in the new century. The business theorists' new enthusiasm for design is having an impact and the international reputation of British designers continues to grow. As a result, design is now moving closer than ever before to the heart of the UK's industrial and social agenda.

We must make the most of this opportunity. As the pace of change quickens over the next few years, design's ability to unlock the innovation process and to provide a crucial competitive edge will become more vital than ever. Design should be considered as essential to business success as marketing or finance. Its new status will help Britain achieve a quantum leap in the international community.

In our product, fashion, graphic, interior and multimedia designers, and our engineers and architects, Britain has the talent to recast its image and to emerge as one of the 21st century's most forward-thinking, creative and innovative nations.

After the restructuring of recent years, the Design Council's close-knit team is now concentrating its efforts on making sure industry and society at large make the best use of design. Our research programme is developing the evidence and the practical tools to help both large and small businesses. Our education programme is improving understanding of design in schools and helping meet future employment needs. Our communication and design programmes are helping to ensure that our key constituencies in business, education and the public sector exploit Britain's design skills to the full.

Naturally, all these changes have imposed special demands on the Design Council team. I would like to warmly congratulate all of them on their efforts over the past year and to offer special thanks to Andrew Summers, Design Council chief executive, to all members of the Council, to the Design Link chairmen and to all the people who give their time so generously. I am convinced that all the effort is already proving worthwhile.

1996 highlights

Design Council Website

The Design Council Website was launched in 1996 and provides a fast, accessible design information resource, directing users to the wealth of design advice, information and services in the UK. It features hypertext links to a wide range of related organisations, and these links will be expanded to other sites in business, education, media and government. Ultimately we aim to provide the definitive design network. Our Website includes a library of design resources, a selection of features from our quarterly journal, *Design*, and details on the background and history of the Design Council.

http://www.design-council.org.uk/

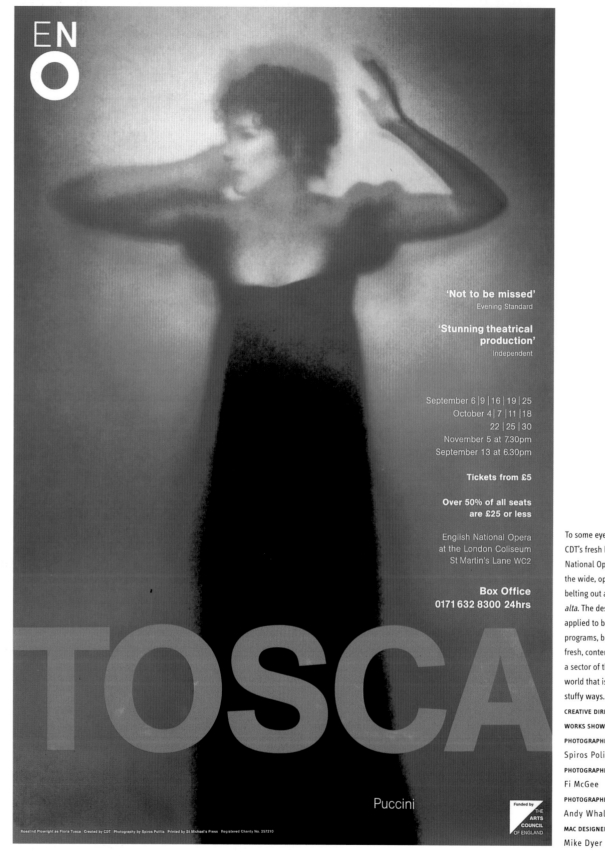

EN
O

'Not to be missed'
Evening Standard

'Stunning theatrical
production'
Independent

September 6 |9 |16 |19 |25
October 4 | 7 |11 |18
22 | 25 |30
November 5 at 7.30pm
September 13 at 6.30pm

Tickets from £5

Over 50% of all seats
are £25 or less

English National Opera
at the London Coliseum
St Martin's Lane WC2

Box Office
0171 632 8300 24hrs

TOSCA

Puccini

Rosalind Plowright as Floria Tosca | Created by CDT | Photography by Spiros Politis | Printed by St Michael's Press | Registered Charity No. 257210

Funded by
THE
ARTS
COUNCIL
OF ENGLAND

To some eyes, the big, bold O in CDT's fresh logo for the English National Opera (ENO) may evoke the wide, open mouth of a singer belting out an aria *a voce molto alta*. The design scheme overall, applied to banners, posters, and programs, breathes a note of fresh, contemporary elegance into a sector of the performing arts world that is known for its rather stuffy ways.

CREATIVE DIRECTOR/DESIGNER OF ALL WORKS SHOWN: Neil Walker
PHOTOGRAPHER, *Tosca* poster: Spiros Politis
PHOTOGRAPHER, *La Traviata* poster: Fi McGee
PHOTOGRAPHER, Repertory leaflets: Andy Whale
MAC DESIGNER, *La Traviata* poster: Mike Dyer

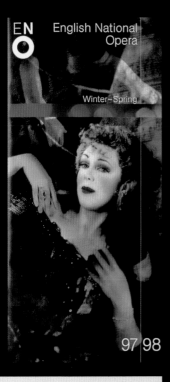

English National Opera

EN O

Winter–Spring

97 | 98

EN O

New Production

Verdi

La traviata

September 12 | 14 | 17 | 19 | 26 | 28
October 1 | 8 | 11 | 16 | 19 | 24 | 28
November 1 | 7 | 15 at 7.30pm
October 5 at 6.30pm

New production sponsored by

🔻 ⚜ Schroders

Xerxes

Handel
Text Minato

February 6 | 11 | 13 | 20 | 23
March 4 | 6 at 7.00pm
February 28 Early Start at 6.30pm
March 4 sign-interpreted and
audio-introduced performance

'Delightfully stylish...undoubtedly one of the most
effective Handel stagings of recent years'
Rodney Milnes, Times

'One of the outstanding Handel productions of our time...'
Robert Henderson, Daily Telegraph

'An evening of many delights'
David Murray, Financial Times

Handel's *Xerxes* is witty, moving and unfailingly melodious.
Nicholas Hytner's stylish production, which has been
acclaimed by audiences around the world, perfectly
captures the straight-faced formality of the music and story
in a surreal world of trimmed hedges, uniformed flunkies
and serried ranks of deck chairs... Are we in a museum or
a dream of the eighteenth century?

New Company Principal Sarah Connolly, familiar as the
Messenger in Monteverdi's *Orfeo*, sings the title role. Janis
Kelly is Romilda, with whom the susceptible king falls in
love. Xerxes' brother and rival in love is sung by the young
Polish counter-tenor Artur Stefanowicz in his British début.
Romilda's scheming sister Atalanta is sung by the 1994
Kathleen Ferrier Memorial Prize winner Susan Gritton,
whose Handel is familiar to ENO audiences from *L'Allegro*
last season. ENO favourites include Jean Rigby as Amastris,
who disguises herself in order to spy on her betrothed, and
Mark Richardson as the Commander of Xerxes' army. The
conductor is Noel Davies.

Performances end at approximately 10.40pm
(February 28 at 10.10pm)

Original production supported by
English National Opera Trust

Now turn to page 20 for details of *How to Book*
Box Office: 0171 632 8300

Xerxes	
Sarah Connolly	
Romilda	
Janis Kelly	
Arsamenes	
Artur Stefanowicz*	
Atalanta	**Conductor**
Susan Gritton	Noel Davies
Amastris	**Original Director**
Jean Rigby	Nicholas Hytner
Ariodates	**Revival directed by**
Mark Richardson	Emma Jenkins
Elviro	**Designer**
Christopher Booth-Jones	David Fielding
	Lighting Designer
	Paul Pyant
	Translation
	Nicholas Hytner
	*Denotes house début

PRINCIPALS: Fabian Monheim,
Sophia Wood
FOUNDED: 1994

3 Bromley Place
Conway Street
London W1P 5HB
TEL (44) 171-323-0861
FAX (44) 171-323-0861

Design in all its forms has long reflected the social and aesthetic values of its times, but can graphic design actually foster a lifestyle on its own? If so, German-born Fabian Monheim and his former girlfriend-turned-business partner Sophia Wood, a Swede, have touched upon an irrepressibly vivacious mix of good looks and pixieish charm that cheerlead for a well-styled environment filled with bright colors and perky vibes. Monheim and Wood met when they were both students at Central Saint Martins College of Art and Design; there, they completed their first commercial project, a logo for furniture designer Tom Dixon. Today, operating as Fly, they both jokingly admit they are glad they endured a personal relationship on the road to their professional partnership. "We know what we're dealing with," Monheim quips. So does a wide range of eager clients, including architects, restaurateurs, high-end retailers, fashion designers, and, more recently, both independent

and big-budget moviemakers. Monheim and Wood's work has been well-received, too, in perennially style-hungry Japan. Fly's sources include 1940s catalogs, the free-and-easy feel of snapshot photography, the clean lines of European modernism, and fun, familiar pop colors. The team's creative strategy: "I pick words I like the sound of," Wood says, "and Fabian is the picture boy." The duo has designed magazines, promotional material, furniture, interiors, packaging, and film-title sequences. To handle the many original T-shirt designs that Fly creates for fashion labels in the United Kingdom, Italy, and Japan, Monheim and Wood even set up a small subsidiary. Its name, not surprisingly, is Flea.

FLY

Fly's calendar is a promotional piece for the studio. "Instead of Mondays and Tuesdays, etc.," the designers note, "we have 'snappy-shoes days,' and 'second-most-anticipated days,' and 'Egyptian porno-fantasy days.'"
DESIGN: Fabian Monheim, Sophia Wood
CONTRIBUTOR: Lomo

go!
(but come back)

july

think
whohaa

01
02
03
04
05
06
07
08
09
10
11
12
13
14
15 goodnameday
16 morethantwobiscuitsday
17 workonlythreehoursday
18
19
20
21
22
23
24
25
26
27
28
30
31

may

Fly created a colorful visual-identity and decorative graphics program for Honeybee, a self-styled "waffles and tea house" located in the train station in Kyoto, Japan. In addition to wall graphics, ceramics, and a color scheme, Fly produced paper bags, aprons, T-shirts, and more.

ART DIRECTORS/DESIGNERS: Fabian Monheim, Sophia Wood
FURNITURE: Michael Young
LIGHTING: Christophe Pillet
PRODUCER: Yoichi Nakamuta

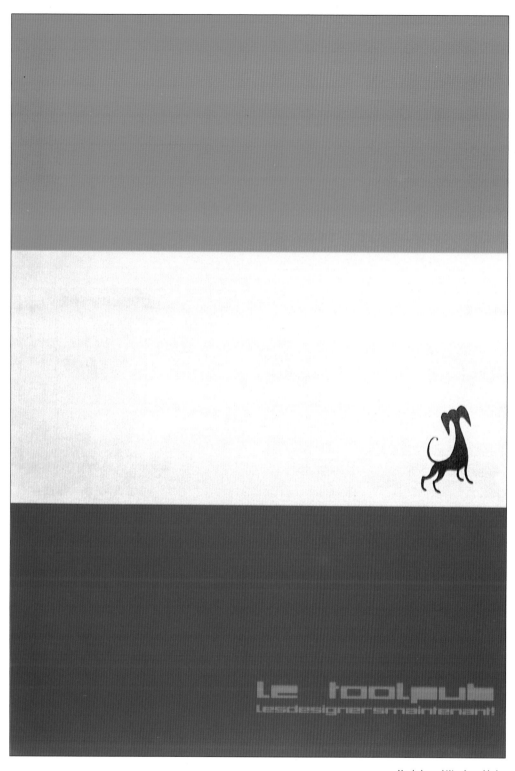

le toolpub
Lesdesignersmaintenant!

Monheim and Wood provided
the art direction for this issue
of *le toolpub*, a magazine about
furnishings and style produced
in Tokyo by Yoichi Nakamuta
of E&Y Gallery, one of Japan's
best-known retailers of high-
end, designer-name furniture.
This issue focuses on French
designers of furnishings.
TYPOGRAPHER: Special typeface
inspired by Tati logo created
by Jamie J. Johnson
ILLUSTRATOR: Yum-Yum

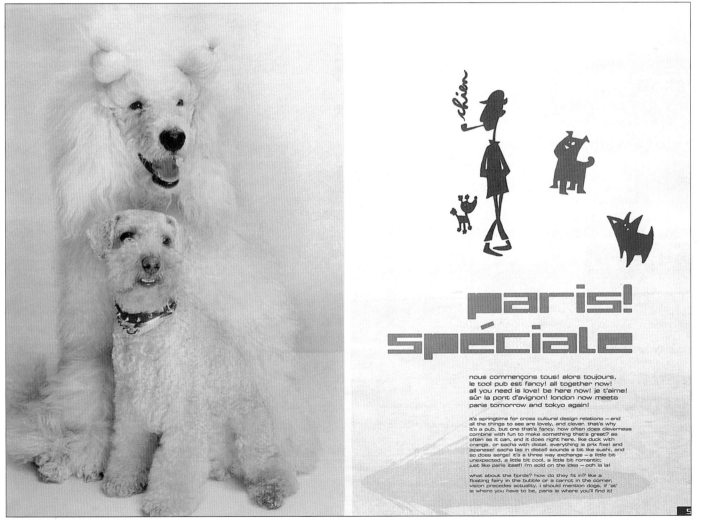

MICHAEL SODEAU PARTNERSHIP

Simple line drawings on the back of this small, horizontal-format pamphlet for furniture, lighting, and housewares designer Michael Sodeau echo the basic, organic shapes of the objects that appear in photographs inside the folded piece.

ART DIRECTORS: Fabian Monheim, Sophia Wood

DESIGNERS: Fabian Monheim, Sophia Wood

PHOTOGRAPHER: David Simmonds

ILLUSTRATOR: Michael Sodeau

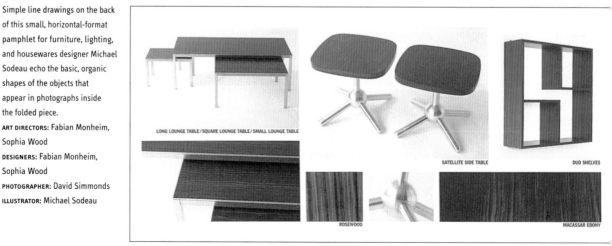

LONG LOUNGE TABLE/SQUARE LOUNGE TABLE/SMALL LOUNGE TABLE

SATELLITE SIDE TABLE

DUO SHELVES

ROSEWOOD

MACASSAR EBONY

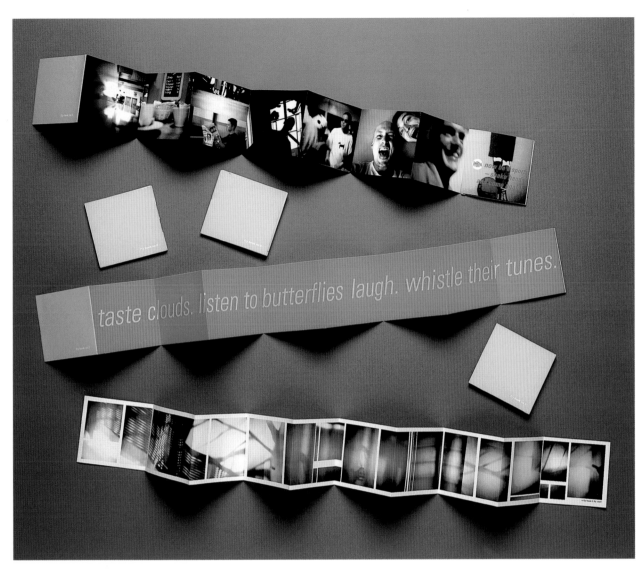

Fly's urban, laid-back spirit and design-as-lifestyle ethos come across vividly in these tiny, accordion-fold promo booklets for the studio, a batch of which are offered in a plain, brown-paper bag. Each "Flybook" is packed with abstract graphics or snapshots that evoke one everyday theme, from riding the subway to walking around snapping pictures with a cheap camera.

ART DIRECTORS: Fabian Monheim, Sophia Wood

DESIGNERS: Fabian Monheim, Sophia Wood

PRODUCERS: Fabian Monheim, Sophia Wood

CONTRIBUTORS: Otto Dietkerdes, Karl Hyde, Tim Marshall, Simone White, Dominik Monheim, Thomas Q. Napper, Graham Wood

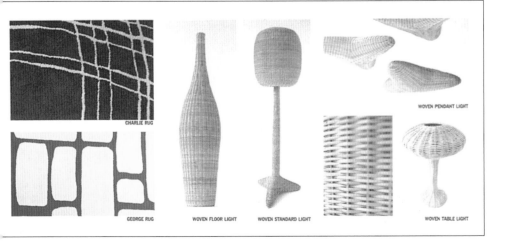

CHARLIE RUG

GEORGE RUG

WOVEN FLOOR LIGHT

WOVEN STANDARD LIGHT

WOVEN PENDANT LIGHT

WOVEN TABLE LIGHT

PRINCIPALS: Vince Frost,
Derek Samuel
FOUNDED: 1994
NUMBER OF EMPLOYEES: 4

11 Great Sutton Street
London EC1V 0BX
TEL (44) 171-490-7994
FAX (44) 171-490-7995

Boldness, clarity, and craftsmanship characterize Vince Frost's signature work, such as his layouts for the magazine *Big* and his 1996-1997 catalog for the British publisher 4th Estate. Frost studied at the West Sussex College of Design and freelanced for Howard Brown and for Pentagram before joining the latter firm in 1989. At the age of twenty-seven, he became its youngest associate; there, he made his name working on *P*, a Polaroid publication. Frost established his own company in 1994. His designs for *Big*, for a picture library called Photonica, and for the magazine of the *Independent*, one of Britain's leading newspapers, can exude an eloquent, even lush quality despite their typical spareness and often generous expanses of bright, white space. Frost's layouts are staging areas and performance spaces in which silhouetted images and large-scale display type come together with an impact that relies more on a sense of their own physicality than it does on clever visual puns. (Frost's keen interest in the look and feel of classic letterpress type is worth noting.) Recently, Condé Nast tapped Frost to design *Vogue*'s new Japanese-language edition. Despite the increasing workload that has come with greater renown, he and his colleagues—Derek Samuel, Andrew Collier, and Melanie Mues—are striving to maintain the sense of control and immediacy that have been hallmarks of their small studio.

FROST DESIGN

Vince Frost's fascination with the physicality of type and the sense of hands-on craftsmanship that are hallmarks of his work are evident in these bold layouts for *Big*, an alternative magazine about culture.

ART DIRECTOR: Vince Frost

BigMagazine Action Nine

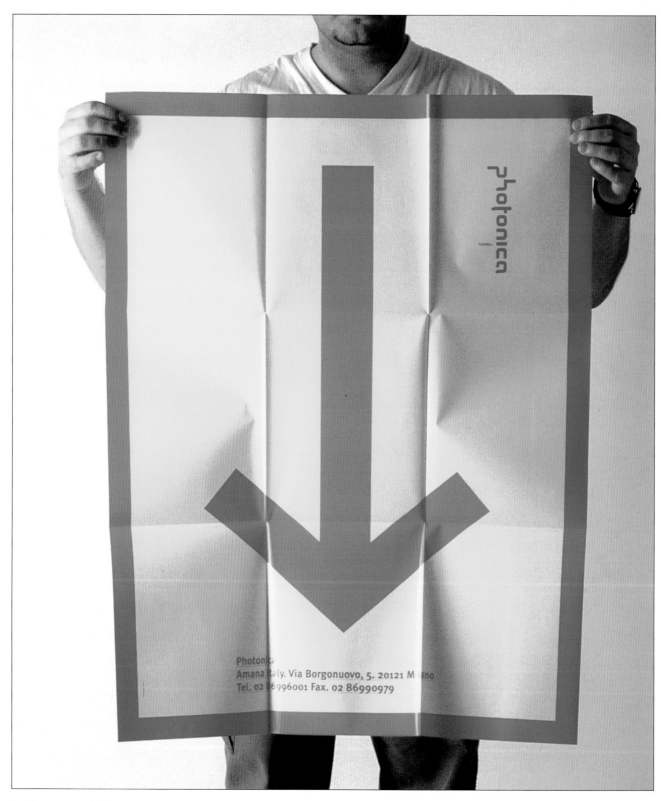

Sometimes a message simply
stated is the most powerful one.
Here, a big, bold arrow points to
Photonica's address in a poster
announcing the company's new
office in Milan.
ART DIRECTOR: Vince Frost
DESIGNERS: Vince Frost,
Andrew Collier

Pages of large, justified display type whose treatment recalls etched or frosted glass evoke a sense of craftsmanship and durability in a catalog for Fusion Glass, Ltd., a British glass-manufacturing company.

ART DIRECTOR: Vince Frost
DESIGNER: Vince Frost

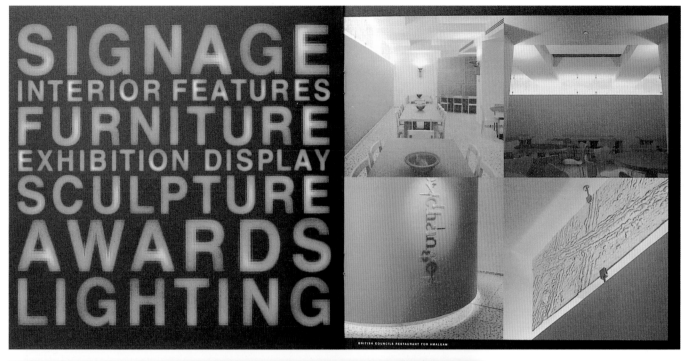

SIGNAGE
INTERIOR FEATURES
FURNITURE
EXHIBITION DISPLAY
SCULPTURE
AWARDS
LIGHTING

BRITISH COUNCILS RESTAURANT FOR AMALGAM

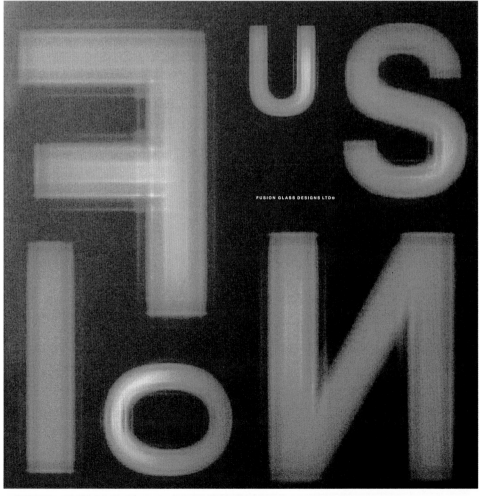

FUSION

FUSION GLASS DESIGNS LTD®

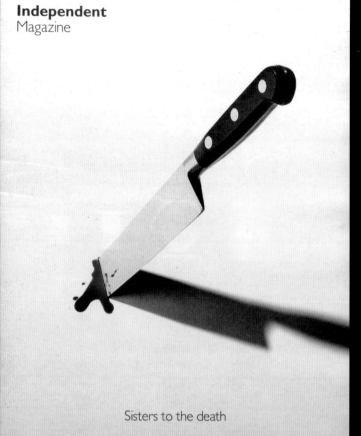

Independent
Magazine

Sisters to the death

Independent
Magazine

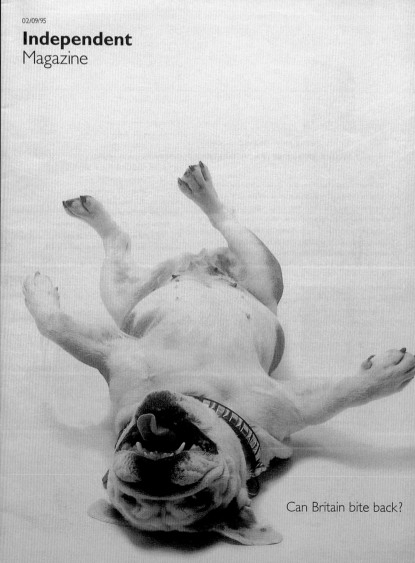

Can Britain bite back?

Strong symbolism and visual puns figure prominently in the spare but eloquent covers that Frost designed for the weekend magazine supplement of the *Independent*, one of Britain's leading newspapers. Frost worked on a complete design overhaul for the paper but backed out when it became clear that the *Independent*, bound by convention, would not undertake the bold new look he had proposed.

ART DIRECTOR: Vince Frost
PHOTOGRAPHERS: Giles Revell,
Matthew Donaldson

serif type, and simple, powerful
image-emblems by the noted
photographer Albert Watson
evoke an appropriate tone of
pride and distinction.
ART DIRECTOR: Vince Frost

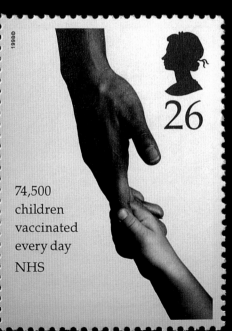

74,500
children
vaccinated
every day
NHS

26

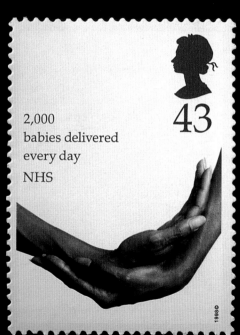

2,000
babies delivered
every day
NHS

43

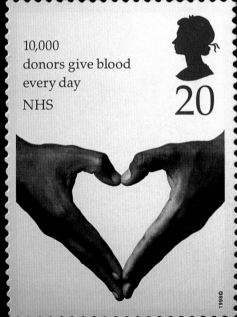

10,000
donors give blood
every day
NHS

20

PRINCIPALS: Peter Miles, Damon
Murray, Stephen Sorrell
FOUNDED: 1990

33 Fournier Street
Spitalfields
London E1 6QE
TEL (44) 171-377-2697
FAX (44) 171-247-4697

A sense of ambiguity and of provocative, sometimes even cryptic allusion pervades the work of Fuel, a trio of young designers that includes Peter Miles, Damon Murray, and Stephen Sorrell. The partners joined creative forces when still at the Royal College of Art, where they produced several issues of an original magazine, *Fuel*. Miles, Murray, and Sorrell are known for working in a mode as imagistic as its resulting posters, CD covers and motion graphics are oddly memorable. The self-awareness of their designs seems to call a viewer's attention to the thinking that inspires them and to the creative processes that give them visible form. Considering the designers' collective art-school background, perhaps the influence of a lingering conceptualist strain in contemporary art and of postmodernism's preoccupation with the manner in which messages are constructed and conveyed comes as no surprise. Fuel has contributed to high-profile ad campaigns for Levi-Strauss, MTV Europe, Microsoft, and Caterpillar, and has created graphics for various record labels. The team's designs and the ideas behind them were collected in book form when Booth-Clibborn Editions published *PURE Fuel* in 1996. That volume brought together snippets of Fuel's source material, too, from anonymously designed product-instruction manuals to cartoon illustrations and computer graphics. Fuel's short films have been shown in avant-garde festivals; more recently, its commercials for the Heathrow Express train service, produced entirely on Apple Macintosh computers, debuted on British television.

FUEL

Bright color is the potent, prominent element in this cover design for a music CD on the Rough Trade label.
CREATIVE DIRECTORS: Peter Miles, Damon Murray, Stephen Sorrell
ART DIRECTORS: Peter Miles, Damon Murray, Stephen Sorrell

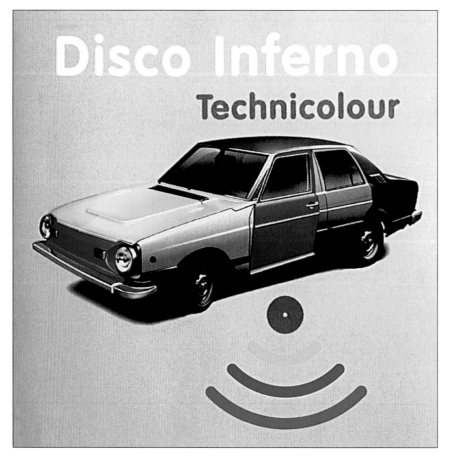

Fuel concocted this startling image for a spread in the magazine of the *Independent*, one of Britain's leading, national newspapers, in a section devoted to artists' original projects.
CREATIVE DIRECTORS: Peter Miles, Damon Murray, Stephen Sorrell
ART DIRECTORS: Peter Miles, Damon Murray, Stephen Sorrell
PHOTOGRAPHER: Matthew Donaldson

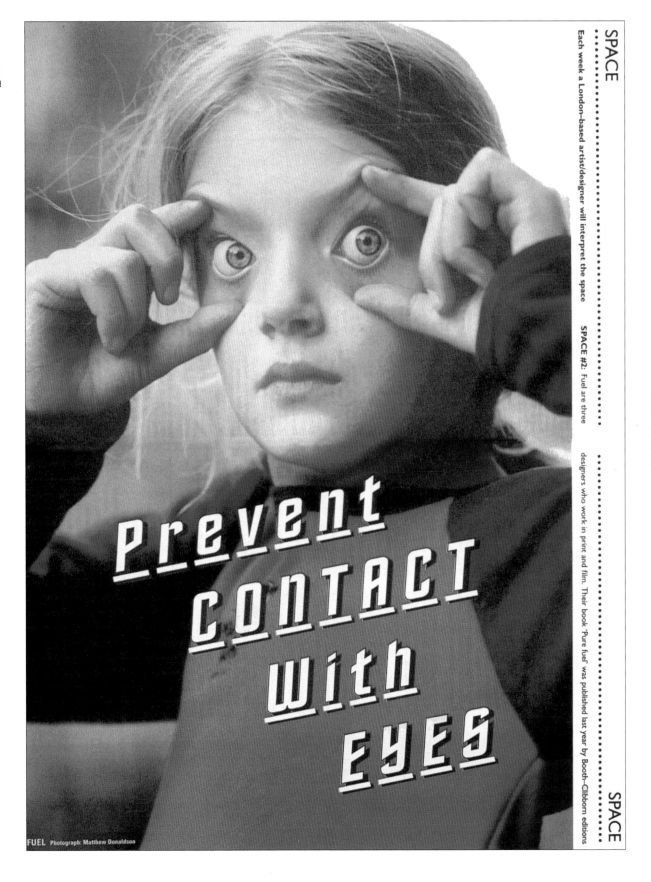

SPACE

Each week a London-based artist/designer will interpret the space

SPACE #2: Fuel are three

designers who work in print and film. Their book 'Pure fuel' was published last year by Booth-Clibborn editions

SPACE

Prevent Contact With Eyes

FUEL Photograph: Matthew Donaldson

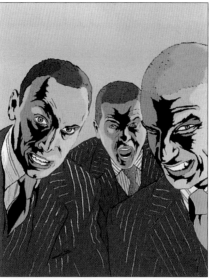

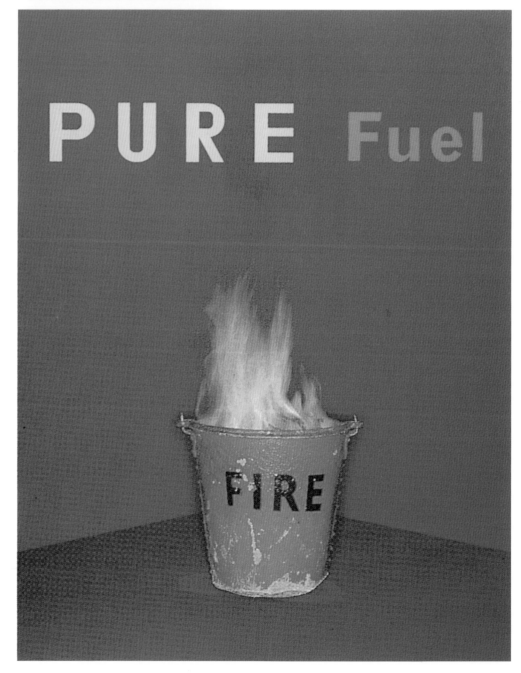

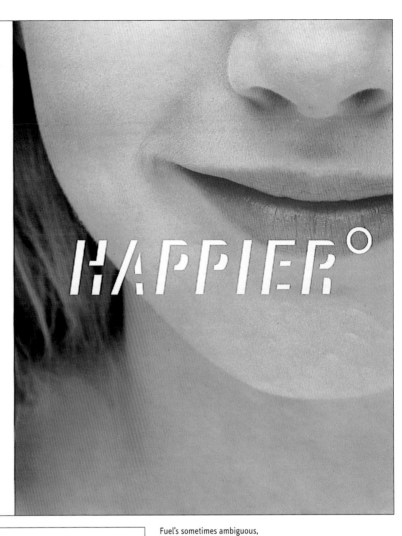

INTE
FR
CRE
O
YO
MONEY

HAPPIER°

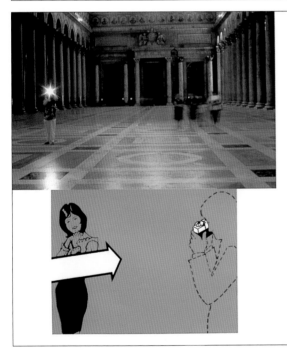

Fuel's sometimes ambiguous, always provocative work and the ideas behind it were collected in *PURE Fuel,* a hefty volume issued in 1996 by Booth-Clibborn Editions, a leading British publisher of books about art and design. These layouts from the book and from the small sampler that preceded its publication show something of the scope of this three-man design team's interests and influences, from anonymously designed product-instruction manuals to cartoon illustrations.

CREATIVE DIRECTORS: Peter Miles, Damon Murray, Stephen Sorrell
ART DIRECTORS: Peter Miles, Damon Murray, Stephen Sorrell

" The day will come

Famous for 15 minutes
Mei-Ha Tsang and Heathrow Express
Designer

Fuel's delight in a fusion of type
and image that can be oddly
ambiguous or cleverly allusive,
and at the same time propelled by
its own internal energy, finds a
strong commercial application in
its spots for the Heathrow
Express train service that links
one of London's main airports
with the city center.
ART DIRECTORS: Peter Miles,
Damon Murray, Stephen Sorrell
CREATIVE DIRECTORS: Peter Miles,
Damon Murray, Stephen Sorrell

Famous for 15 minutes
David Giroux and Heathrow Express
Banker

 Heathrow **express**
Famous for 15 minutes

15 minutes "
Andy Warhol

Heathrow **express**
Famous for 15 minutes

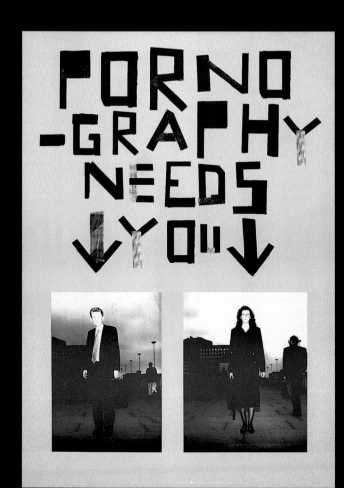

Fuel created this typeface and
poster for *Fuse;* its message calls
attention to an obsessive side of
human nature that resides behind
many an ordinary façade.
CREATIVE DIRECTORS: Peter Miles,
Damon Murray, Stephen Sorrell
ART DIRECTORS: Peter Miles, Damon
Murray, Stephen Sorrell
PHOTOGRAPHERS: Peter Miles,
Damon Murray, Stephen Sorrell

PRINCIPAL: Richard Davies
FOUNDED: 1994
NUMBER OF EMPLOYEES: 18

332 B Ladbroke Grove
London W10 5AH
TEL (44) 171-565-0022
FAX (44) 171-565-0020

When Richard Davies established Good Technology a few years ago, the studio became one of the United Kingdom's first to specialize in design for multimedia and new media. In practice, this has come to mean concentrating on innovative design schemes for Web sites and CD-ROM projects. Good Technology describes its approach in a summary of its mission and aesthetics: "The Web is part print, part television and part CD-rom. A well-designed site should combine these elements to create a wholly new, enhanced medium that is greater than the sum of its individual parts." Between them, the firm's lead designers, Dan Harrison, Justin Copplestone, Nickie Hirst and Rob Corradi, have had extensive experience in design for print as well as new media both within the United Kingdom and in continental Europe; Hirst has also taught new-media design at the university level. In Web sites like the one that Good Technology created for Audi, the studio has captured and reflected precisely the corporate identity and product image that the automaker has projected in its familiar print and TV campaigns. In their work, these designers do not want to forsake the information-rich quality of printed material; at the same time, they try to capitalize on the interactive characteristics that are unique to the Web. In sites like Audi U.K.'s, the designers have developed techniques or components to "bridge the gap," they say, between these communication methods. With its energy, style, and flexibility, Good Technology's design strategy is helping to define how computer-delivered information, at its best, can and should function and look.

GOOD TECHNOLOGY

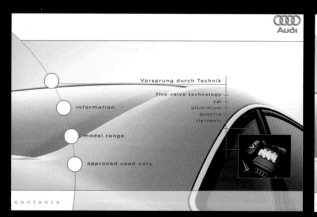
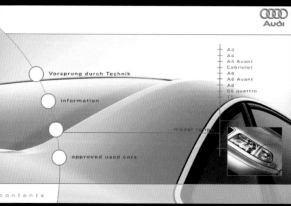

With clean, uncluttered pages that exude a sense of spacious-ness, Good Technology's design for Audi U.K.'s Web site expresses the qualities of intelligence, innovation and sophistication that are associated with this auto brand. To bridge the gap between the information-delivery features of print and TV that a Web site offers or evokes, and to capitalize on its uniquely interactive character, the studio's designers created short, animated "adverts," as they call them, to highlight particular aspects of Audi's technology or product range. A user encounters them while moving among the site's main sections.

CREATIVE DIRECTOR: Steve Stretton

ART DIRECTORS: Justin Copplestone,

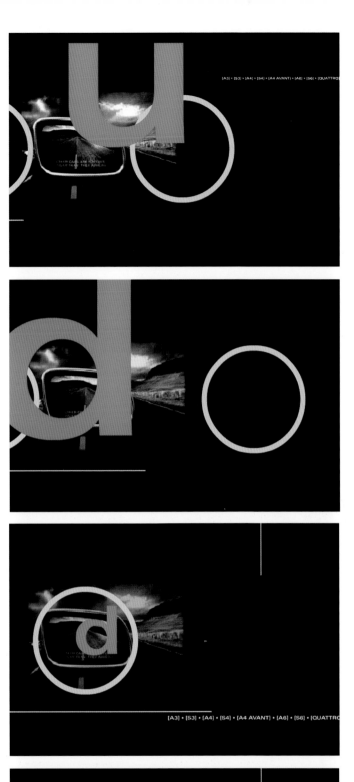

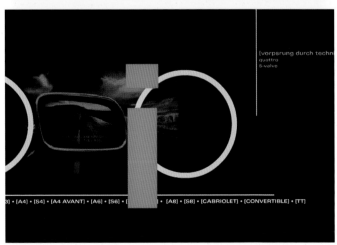

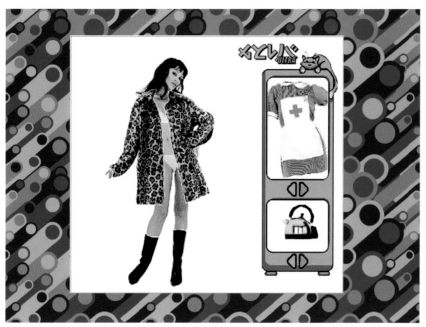

Good Technology used Japanese-style *manga* (comic book) illustrations and bright colors for its Web site for Deconstruction Records pop star Kylie Minogue. Its perkiness, along with such features as its drag-and-drop "Dress Kylie" paper-doll-on-a-screen game, cater to the goofy spirit of pop-music fandom.

CREATIVE DIRECTOR: Chris McGrail
ART DIRECTOR: Kylie Minogue
DESIGNERS: Chris McGrail,
Tom Hume
ILLUSTRATOR: Joe Berger
JAVA PROGRAMMER: Tom Hume

With its broad, horizontal format and crisp articulation of a computer-savvy, techno-inspired aesthetic, Good Technology's Web site for Republica, a rock band, was developed to coincide with the release of its *Speed Ballads* album on Deconstruction Records. Visually rich and stylish, it exploits the use of full color on the Web.

CREATIVE DIRECTOR: Nickie Hirst

ART DIRECTOR: Nickie Hirst

ADDITIONAL DESIGN AND PROGRAMMING: Rob Corradi

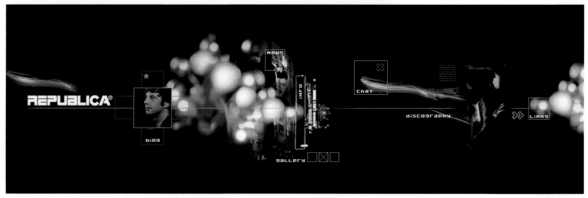

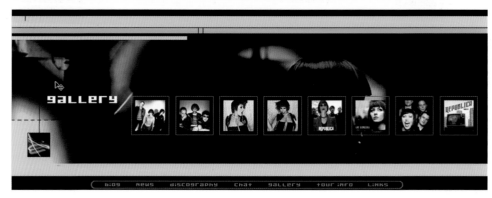

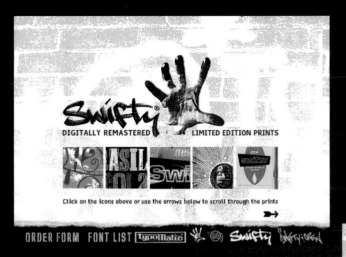

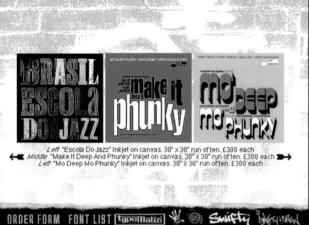

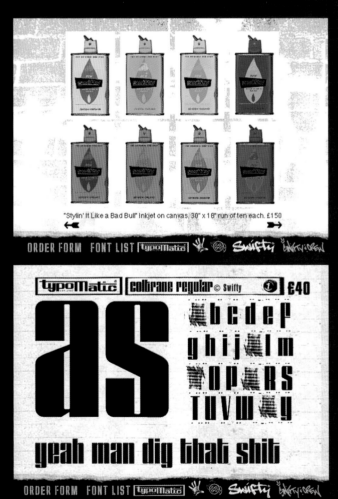

A Web site for the London-based graphic designer Swifty, of the Swifty Typografix studio, captures the flavor of its client's edgy, experimental work and gives him a bold setting in which to promote and sell his designs. The site features the "Swifty Scrapbook," an online portfolio of graphics created for print and TV. The site also serves as a platform from which Swifty can sell limited-edition artworks, based on his designs, and his original typefaces.

CREATIVE DIRECTOR: Swifty
ART DIRECTOR: Swifty
DESIGNER: Dan Harrison

PRINCIPALS: Paul Neale,
Andrew Stevens
FOUNDED: 1990
NUMBER OF EMPLOYEES: 1

Unit 410
31 Clerkenwell Close
London EC1R 0AT
TEL (44) 171-608-2441
FAX (44) 171-251-1004

Eclectic is as eclectic does, but the strengths of diverse design solutions and of routinely playing an unexpected card often offer their own rewards. So the range of projects that Paul Neale and Andrew Stevens of the oddly named Graphic Thought Facility, with a hint of nerdy chic—or cheek—repeatedly seems to suggest. Neale and Stevens got to know each other as students in the Royal College of Art's renowned post-graduate (master's-degree level) graphic-design program. They started out collaborating with Nigel Robinson, who left to focus on illustration; after stretching their imaginations and resources in their early years on smaller, low-budget jobs that were, Stevens recalls, "Why Not Associates' second-hand clients," the two-man team became known for innovative, two-color theater posters and for a sense of economy, born of necessity, that made their designs striking and memorable. Buoyed by wide-ranging interests, including obsolete technology and football (soccer), Neale and Stevens are also blessed with an instinctive ability to soak up and distill in images, color, and type the spirit and energy—what they call the all-important "vibe"—of a client's product, service, or event. For instance, with a restaurant, Stevens says, "There's the light, materials, the way things are done; it's picking up on that." He adds: "Results come from personal notions of what we think a job should look like." Graphic Thought Facility's work may embrace a design cliché as easily as it can subvert it; the firm's work can be mostly photo-driven or primarily illustrative, cool or warm, full of contradiction, or just clever enough, but never self-consciously cute.

GRAPHIC THOUGHT FACILITY

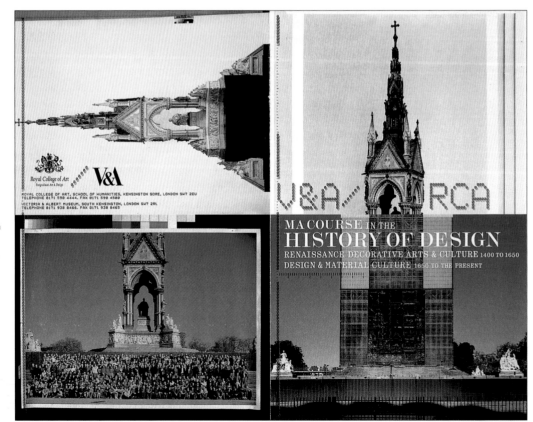

A catalog for the history of design program offered by the Royal College of Art in conjunction with the Victoria & Albert Museum seems to be, in terms of its looks, as much about the making of a publication of this kind as it is, in terms of function, an effective conveyor of information about the subject it describes.
CREATIVE DIRECTORS: Paul Neale, Andrew Stevens
ART DIRECTORS: Paul Neale, Andrew Stevens

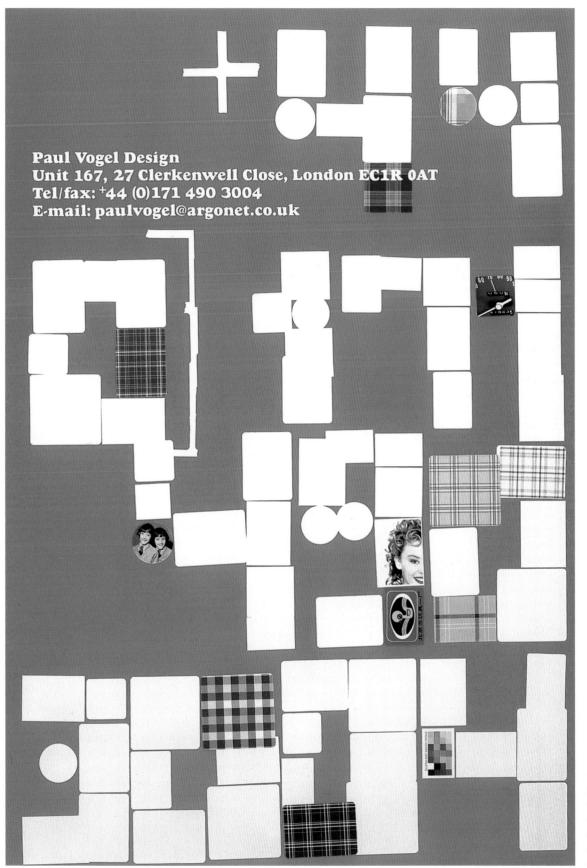

Paul Vogel Design
Unit 167, 27 Clerkenwell Close, London EC1R 0AT
Tel/fax: +44 (0)171 490 3004
E-mail: paulvogel@argonet.co.uk

Neale and Stevens produced this
promotional poster for the textile
designer Paul Vogel.
CREATIVE DIRECTORS: Paul Neale,
Andrew Stevens
ART DIRECTORS: Paul Neale,
Andrew Stevens

Graphic Thought Facility's work often subverts the familiar or sends up a design—or design-world—cliché. Here, sheets from a common adhesive-notes pad and the jottings on them evoke the brainstorming phase of the creative process in a poster for the fashion designers Antoni & Alison.

CREATIVE DIRECTORS: Paul Neale, Andrew Stevens

ART DIRECTORS: Paul Neale, Andrew Stevens

PHOTOGRAPHER: Andrew Penketh

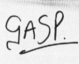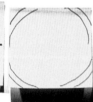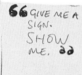

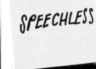

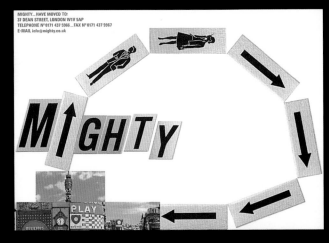

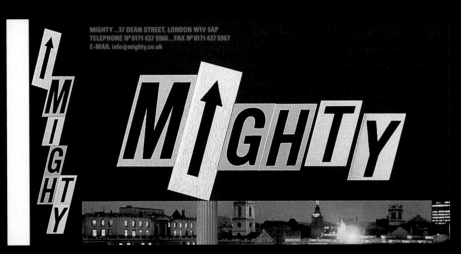

Using familiar, even bland graphic elements in new contexts can give them new meaning, rejuvenate their character, and make for striking, clever forms of visual communication. Here, Neale and Stevens employ generic, hardware-store adhesive letters and symbol signs in a "visual identity" scheme—letter-head, cards, labels—for Mighty, a film-production company.

CREATIVE DIRECTORS: Paul Neale, Andrew Stevens

ART DIRECTORS: Paul Neale, Andrew Stevens

Work from London
Graphics, visual languages and culture
A British Council Exhibition

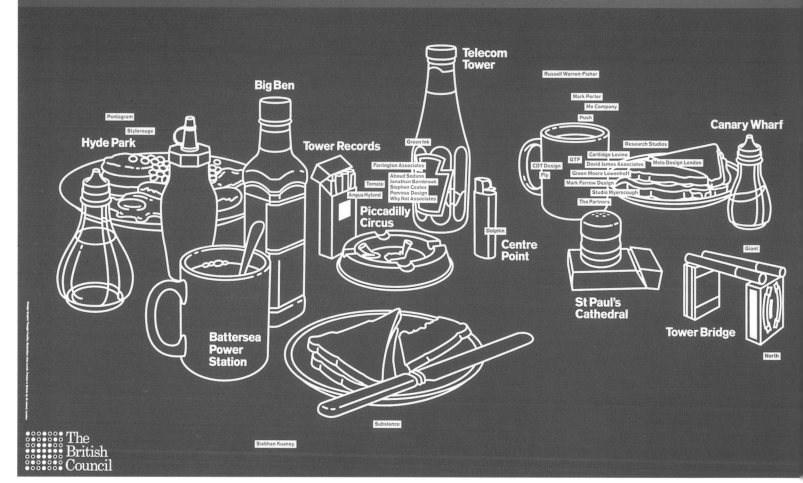

Hyde Park — Pentagram, Stylorouge

Big Ben

Telecom Tower

Tower Records

Green Ink

Farrington Associates
Aboud Sodano
Jonathan Barnbrook
Stephen Coates
Penrose Design
Why Not Associates
Tomato
Angus Hyland

Piccadilly Circus

Russell Warren-Fisher
Mark Porter
Me Company
Push
Research Studios
CDT Design
GTF
Cartlidge Levine
David James Associates
Meta Design London
Fly
Green Moore Lowenhoff
Mark Farrow Design
Studio Myerscough
The Partners

Canary Wharf

Dolphin

Centre Point

Battersea Power Station

Substance

Siobhan Keaney

St Paul's Cathedral

Tower Bridge

Giant

North

The British Council

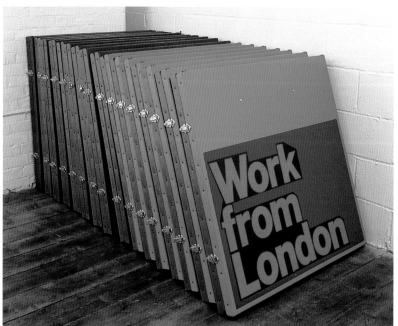

Graphic Thought Facility created a plain-typeface logo for the "Work from London" traveling exhibition sponsored by the British Council, as well as a poster that served as its catalog. An essay and samples of participating graphic designers' works in the show appeared on one side of the poster; on the other was printed a "map" of London—line drawings of dinner-table clutter representing familiar sights and the locations of the designers' offices in relation to them.

CREATIVE DIRECTORS: Paul Neale, Andrew Stevens
ART DIRECTORS: Paul Neale, Andrew Stevens
PHOTOGRAPHER: Andrew Penketh
ILLUSTRATORS: GTF

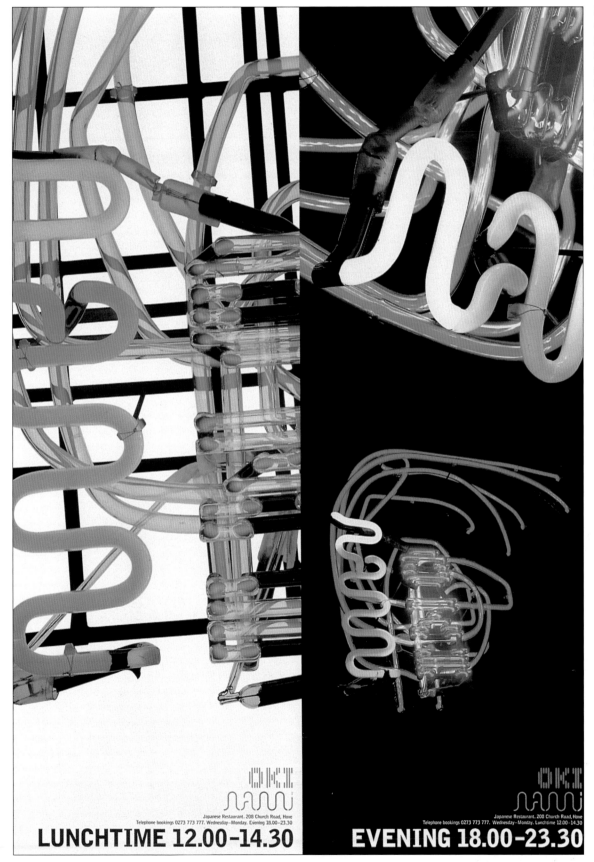

In developing a logo, poster, and related graphics for Okinami, a Japanese restaurant whose name means "big wave," Neale and Stevens actually studied how neon signs are made. Appropriately, they "wrote" part of the eatery's name in neon.

CREATIVE DIRECTORS: Paul Neale, Andrew Stevens

ART DIRECTORS: Paul Neale, Andrew Stevens

PHOTOGRAPHER: Andrew Penketh

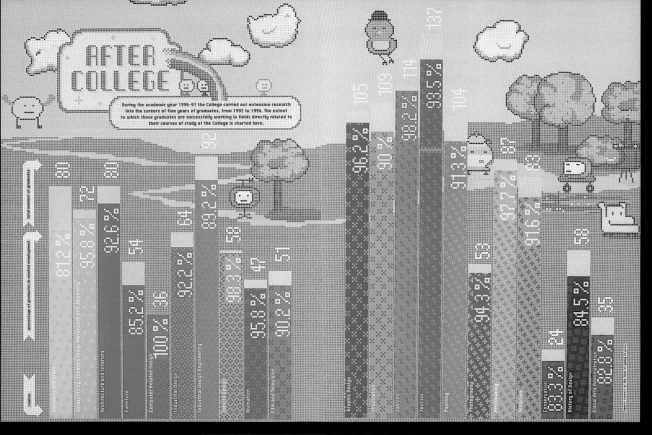

AFTER COLLEGE

During the academic year 1996–97 the College carried out extensive research into the careers of five years of graduates, from 1992 to 1996. The extent to which those graduates are successfully working in fields directly related to their courses of study at the College is charted here.

Graphic Thought Facility's eclectic treatment of the Royal College of Art's catalog of its post-graduate (master's-degree level) programs hints at the sense of experimentation and innovation for which this school, where Neale and Stevens both studied, has become known.

CREATIVE DIRECTORS: Paul Neale, Andrew Stevens

ART DIRECTORS: Paul Neale, Andrew Stevens

ILLUSTRATOR: Kam Tang

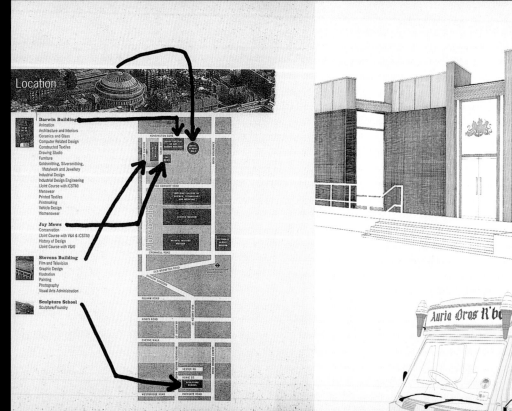

PRINCIPALS: Pierre Vermeir,
Jim Sutherland
FOUNDED: 1988
NUMBER OF EMPLOYEES: 10

46A Rosebery Avenue
London EC1R 4RP
TEL (44) 171-278-4449
FAX (44) 171-837-4666

HGV Design Consultants' portfolio routinely combines sharp wit, intelligent understanding of each assignment's subject matter, and an overall tone of sophistication in projects that reach for aesthetic highs as they seek to direct and inform; often, they also amuse or entertain. Those characteristics are visible in HGV's clever logo and bright, primary-color palette for Techniquest, a national, interactive science center, and in its promotional booklet for Britain's Design Council, an organization that encourages the use of design as a tool to enhance industrial performance. Clarity and strong, basic concepts drive much of HGV's work. "Our job is to communicate, not decorate . . . [to] change perceptions, build loyalties, and express the individual nature of every organization we work with," the design studio says in its mission statement. Founder/creative director Pierre Vermeir, creative director Jim Sutherland, and their collaborators usually achieve that goal with a refreshing economy of graphic means—which does *not* mean minimalist posturing—and with consistently elegant style.

HGV DESIGN
CONSULTANTS

The precisely shaped and positioned question mark that resembles the letter *Q*—alluding to the spirit of investigation and inquiry—gives a special kick to HGV's logo and promotional items that bear the logo for an interactive science museum for children in Cardiff.
CREATIVE DIRECTORS: Pierre Vermeir, Jim Sutherland

TECHNI?UEST

innovation
through
research

The Design Council

process
setting objectives

To build a platform for innovation based on a better understanding of how the design and product development process works, the Design Council has defined research priorities, identified suitable research partners, appointed a Research Advisory Board, and launched two research agendas.

The first was launched in 1994, entitled 'Design Effectiveness'. Under its banner we are putting in place 'building blocks' to enable companies to develop a more effective design process. Areas covered include: benchmarking of world best practice so that companies can measure their own performance in design and development; the understanding of knowledge sharing in new product development; and study of how new approaches to management accounting and budgeting can facilitate innovation.

Following this broad sweep of knowledge which will help companies to get in shape to use design more effectively, we have developed a new research agenda for 1996-99, entitled 'Product Vision'. Its fundamental objective is to help boost the ability of companies to innovate by gaining a better understanding of consumer values, and how new product and service opportunities can be envisaged, embedded, sustained and realised within organisations.

purpose
getting a grip

Innovation is the lifeblood of business and industry. Unless we develop new products, processes and services, we don't move forward. But the development process can go wrong even when all the right resources are in place. The innovation cycle can stutter, as even the most cursory glance at recent economic performance in the UK will confirm.

Every industrial nation is now rethinking the way ahead. Internationally, there is a growing belief that the complex interplay between design and a host of financial, managerial and technical factors holds the key to creating a more robust and competitive economy. Yet the practical understanding and self-help tools needed at company level to truly grasp the issue have yet to be developed.

Some of the necessary knowledge already exists but it languishes in academic journals and has not reached practitioners in design and industry. Other factors have barely been touched by researchers. That is why the Design Council has launched its own research programme. We are building a new knowledge base on the business issues which impact on the design and development process. We aim to give British industry the 'knowledge tools' to really get a grip on innovation in the long term.

The Design Council's new research programme was launched in November 1994 following a major Government commissioned review and restructuring of organisation. The Design Council's purpose today is to improve the UK's competitiveness through better use of design, which is fundamental to the creation of innovative products, processes and services. Our research initiatives respond to this theme. Importantly, we recognise the need to strike a balance between research which is accessible in the short term to help companies improve in such areas as product quality, and longer term studies aimed at the less well understood, more ideal aspects of managing innovation.

In this promotional booklet, crisp black-and-white photography in the service of clever visual puns helps deliver the message from Britain's Design Council that uniting creativity and commerce is valuable.

CREATIVE DIRECTORS: Pierre Vermeir, Jim Sutherland

PHOTOGRAPHER: Duncan Smith

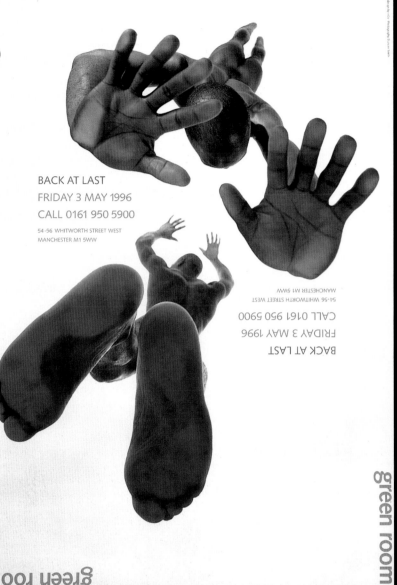

green room

green room

BACK AT LAST
FRIDAY 3 MAY 1996
CALL 0161 950 5900

54-56 WHITWORTH STREET WEST
MANCHESTER M1 5WW

BACK AT LAST
FRIDAY 3 MAY 1996
CALL 0161 950 5900
54-56 WHITWORTH STREET WEST
MANCHESTER M1 5WW

green room

green room

In posters, signage, and
promotional materials, HGV's
designers play off the square-
shaped form of the repeated
name of the Green Room in
this logo they created for the
Manchester arts center.
CREATIVE DIRECTOR: Pierre Vermeir
PHOTOGRAPHER: Duncan Smith

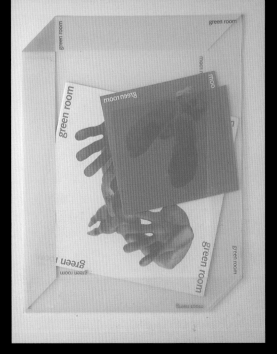

from unforeseen growth

a tailored solution

A simple, imaginative type
treatment on the cover of a
promotional booklet for CWB, a
company that provides information
technology for the financial-
services sector, vividly conveys
the theme of clear thinking for
solutions. The theme is carried
throughout the publication,
reinforced by uncomplicated
photo images and neat,
clean layouts.

CREATIVE DIRECTORS: Pierre Vermeir,
Jim Sutherland

DESIGNER: Stuart Radford

in a complex
world clarity
of thinking

CWB

Information technology for the financial service sector

esprit europe

The world's fastest international train is The Eurostar running at speeds of up to 186 mph to Brussels and Paris

HGV developed a new name and identity for Esprit Europe, the express-delivery service operated by the Eurostar train that connects the United Kingdom and continental Europe. The logo alludes to a speeding train, and its related promotional materials effectively convey a sense of swift service. The plain brown backgrounds refer to familiar parcel-wrapping paper.

CREATIVE DIRECTORS: Pierre Vermeir, Jim Sutherland

PRINCIPAL: Michael Johnson
FOUNDED: 1992
NUMBER OF EMPLOYEES: 5

Studio 6
92 Lots Road
Chelsea
London SW1 0QD
TEL (171) 351-7734
FAX (171) 351-4435

With a background in design and marketing, Michael Johnson says he "cut his teeth" at London's large Wolff Olins firm in the mid-1980s, then worked in graphic design and art direction in Australia and Japan before returning to England to set up his own studio. At first he had a partner named Banks who later left the company—and left it his name. Johnson Banks is known for clever, concept-driven work in which powerfully integrated textual and graphic elements convey messages with a witty, memorable punch. Word play and strong visual puns are hallmarks of much of the studio's output, as in its posters for the Victoria & Albert Museum. The firm's philosophy, its leader observes, is reflected in the legendary American adman George Lois's maxim that "Creativity is the defeat of habit by originality." Thus, says Johnson, he and his close-knit team—account director Georgia Jensen, and designers Luke Gifford, Harriett Devoy, Sarah Fullerton, and Chris Wigan— "are much more involved with words and strategy than most design companies and often start with words rather than with pictures." Their approach has attracted blue-chip clients such as PolyGram and Harrods, and various cultural institutions. For this firm, clearly, a blend of boldness and wit works. "People come to us to communicate," Johnson notes, "not to confuse."

JOHNSON BANKS

The Design Council wanted to make sure that forty-five movers and shakers in the design world would attend a special dinner/ seminar to discuss the value of working together to benefit their entire community. For invitations to the event, Johnson Banks made and sent each invitee a large magnetic card, shaped like a license plate, each bearing one word. The unique invitations only made sense when seen together, combined, to spell out a meaningful, forty-five-word sentence. (Note: All the invitees attended the dinner.)

CREATIVE DIRECTOR: Michael Johnson

For a publicity campaign for an exhibition about William Morris at the Victoria & Albert Museum, one of the studio's major institutional clients, Johnson Banks developed a symbol based on an acanthus leaf that morphs into a motif from a Morris wallpaper design.

CREATIVE DIRECTOR: Michael Johnson

These posters are from a series
the studio created for Britain's
Design Council. They are intended
to be displayed in schools and to
pique children's interest in the
design process by using beautifully
"wrong" images.
CREATIVE DIRECTOR: Michael Johnson

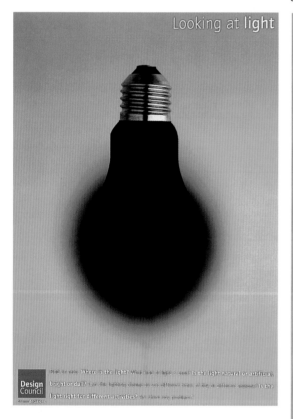

Looking at **light**

Find the area. **Where is the light?** What kind of light is used? Is the light natural or artificial, bright or dull? Can the lighting change to suit different times of day, or different seasons? Is the light right for different activities? Are there any problems?

Design Council
design decisions

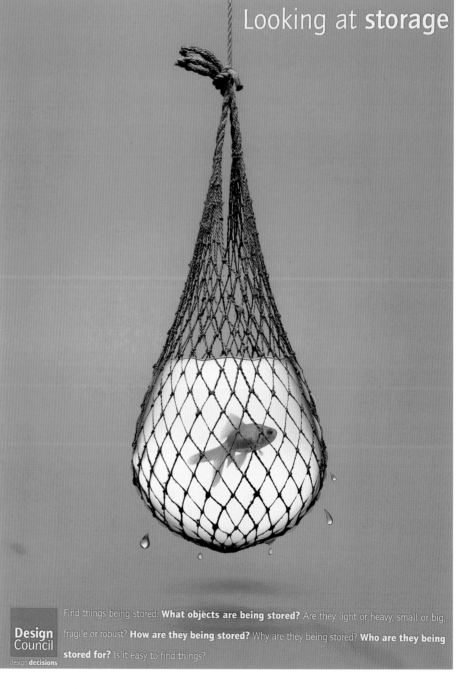

Looking at **storage**

Find things being stored. **What objects are being stored?** Are they light or heavy, small or big, fragile or robust? **How are they being stored?** Why are they being stored? **Who are they being stored for?** Is it easy to find things?

Design
Council
design decisions

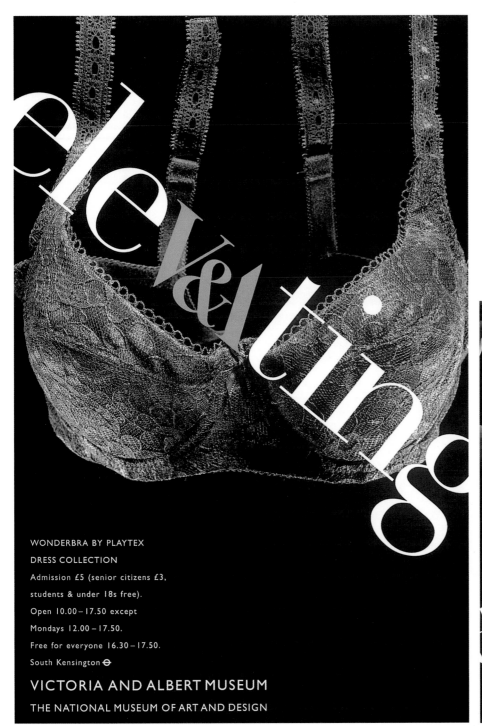

elev&ting

WONDERBRA BY PLAYTEX

DRESS COLLECTION

Admission £5 (senior citizens £3,

students & under 18s free).

Open 10.00 – 17.50 except

Mondays 12.00 – 17.50.

Free for everyone 16.30 – 17.50.

South Kensington ⊖

VICTORIA AND ALBERT MUSEUM

THE NATIONAL MUSEUM OF ART AND DESIGN

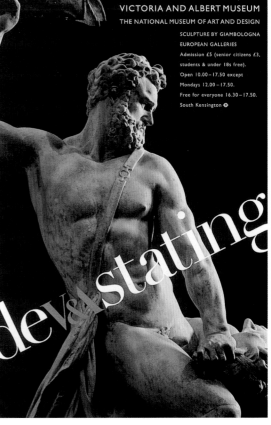

VICTORIA AND ALBERT MUSEUM

THE NATIONAL MUSEUM OF ART AND DESIGN

SCULPTURE BY GIAMBOLOGNA

EUROPEAN GALLERIES

Admission £5 (senior citizens £3,

students & under 18s free).

Open 10.00 – 17.50 except

Mondays 12.00 – 17.50.

Free for everyone 16.30 – 17.50.

South Kensington ⊖

dev&stating

A shot of subdued color highlights
the typographic puns in these
posters promoting the permanent
collections of London's Victoria &
Albert Museum, popularly known
as "The V & A," in which this
abbreviation figures prominently
in large headlines.
CREATIVE DIRECTOR: Michael Johnson

The Modern Poster

A REVIEW OF CONTEMPORARY POSTER DESIGN BY MICHAEL JOHNSON, JOHNSON BANKS

Johnson Banks's strongly concept-driven works are known for being clever and bold, like these two self-promotional posters Michael Johnson created for lectures he has given on the themes of modern posters and simple ideas.
CREATIVE DIRECTOR: Michael Johnson

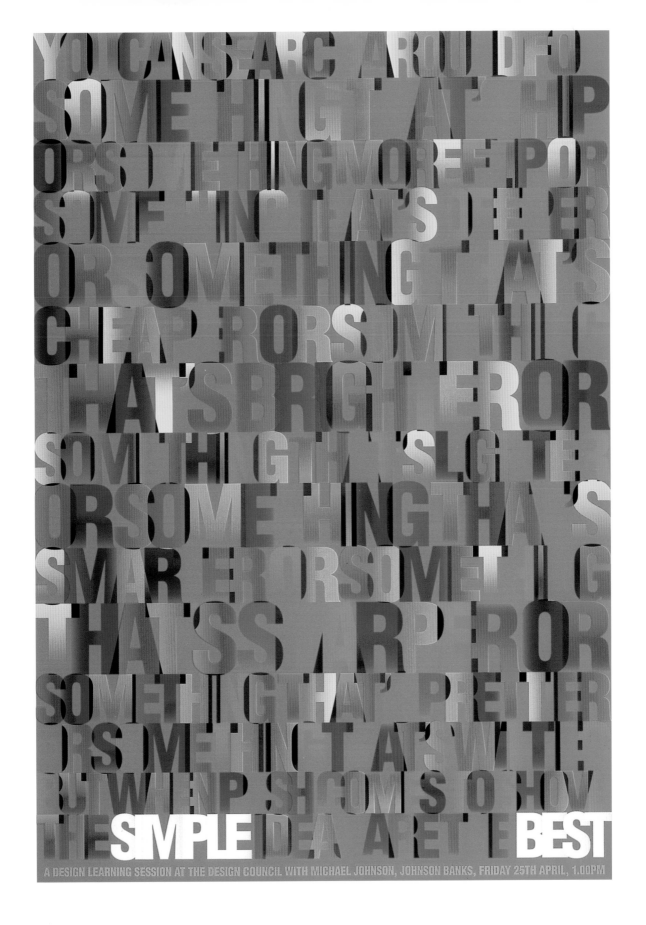

YOU CAN SEARCH AROUND FOR SOMETHING THAT'S HIP OR SOMETHING MORE IPOR SOMETHING THAT'S DEEPER OR SOMETHING THAT'S CHEAPER OR SOMETHING THAT'S BRIGHTER OR SOMETHING THAT'S SLIGHTER OR SOMETHING THAT'S SMARTER OR SOMETHING THAT'S SHARPER OR SOMETHING THAT'S PRETTIER OR SOMETHING THAT'S WITTIER BUT WHEN PUSH COMES TO SHOVE THE SIMPLE IDEAS ARE THE BEST

A DESIGN LEARNING SESSION AT THE DESIGN COUNCIL WITH MICHAEL JOHNSON, JOHNSON BANKS, FRIDAY 25TH APRIL, 1.00PM

PRINCIPALS: Mary Lewis,
Robert Moberly
FOUNDED: 1984
NUMBER OF EMPLOYEES: 30

33 Gresse Street
London W1P 2LP
TEL (44) 171-580-9252
FAX (44) 171-255-1671

"I need a problem, and it must be one I believe in," notes Mary Lewis, the head of design at this renowned studio whose operation she oversees with partner Robert Moberly, a veteran adman. Lewis Moberly is known for carefully considered design solutions that are both inventive and appropriate to clients' needs for branding or delivering information. Lewis eschews cheap gimmicks or "pursuing difference just for the sake of it." Instead, this former president of Britain's Design & Art Direction, the advertising-and-communications-design professional society, steers her creative team through exhaustive research before beginning to design. "I try to unscramble lots of thoughts into something simple," she says, "and then I want to do it beautifully or boldly or bravely." Lewis, who began her career as a fine artist making prints, brings to the studio's work a full understanding of the power of clear, uncluttered composition. "I respond emotionally to design," she adds unabashedly in these style- and theory-loving times. Lewis Moberly's artistically informed, brand-strategic expertise appears in such projects as the firm's brightly colored "Ride the Tiger" campaign for Novartis and its beautifully understated wine and beverage labels. "I don't belong to the 'Where's the big idea?' school of thought," Lewis observes. "Sometimes strength lies in not having one. Knowing what to leave out, what to leave alone—this matters a lot to me."

LEWIS MOBERLY

London's Geffrye Museum is a little institution that traces the history of English domestic interiors through a series of period-styled rooms. Lewis Moberly's logo and related materials for the museum play with the idea of peeking through a keyhole into such cozy, locked-in-time interiors. This secrets-revealing keyhole motif and the sense of discovery to which it alludes figure in all of the studio's graphics for the Geffrye.
DESIGN DIRECTOR: Mary Lewis
DESIGNER: Jimmy Yang

DESIGN DIRECTOR: Mary Lewis
DESIGNER: Rob Howsam
PHOTOGRAPHER: David Lidbetter

DESIGN DIRECTOR: Mary Lewis
DESIGNER: Rob Howsam

Are you thinking about this in the right way?

RRRRRIDE THE TIGER

Think about human resources in a new way. Be imaginative in your thinking. Imagine a programme that encourages positive action, rewards new ideas, initiative, and drive. Imagine a practical programme to help you find new ways to get better results so you can drive yourself and the business forward. Imagine you're riding a tiger.

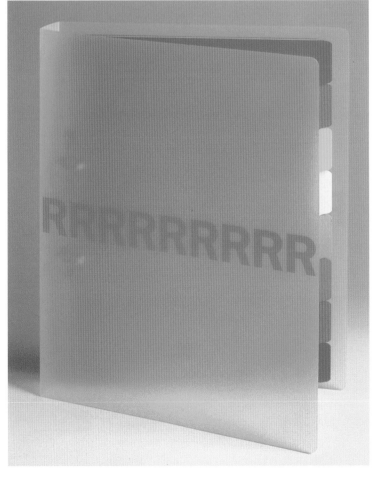

In a project like the graphics scheme for Novartis Consumer Health's human-resources program, for Mary Lewis and her collaborators, "The idea is in the slogan.... Hence the simple graphic execution."
DESIGN DIRECTORS: Mary Lewis, Martin Firrell
DESIGNERS: Bryan Clark, Ann Marshall

Cutting through the clutter of mainstream brand leaders' packages, Lewis Moberly's packaging system for the house brand of film products from Boots, Britain's leading drugstore chain, catches the eye and communicates effectively.

DESIGN DIRECTOR: Mary Lewis
DESIGNERS: Julian Morey, Mary Lewis, Ann Marshall, Stewart Devlin
ILLUSTRATORS: Julian Morey, Stewart Devlin

For the packaging of cookies manufactured by and in Prince Charles's Duchy of Cornwall, Lewis intentionally sought a restrained look. Considering the source and ownership of the brand, she says, "I wanted no regal or romantic concepts. If you've got it, *don't* flaunt it."

DESIGN DIRECTOR: Mary Lewis
DESIGNERS: Mary Lewis, Ann Marshall
PHOTOGRAPHER: David Gill

"I think of the bottle as a person, as a character possessing attitude and stance," Mary Lewis has observed. "In designing the label, I'm creating the clothes." A successful bottle design, she says, "will exude atmosphere and invite touch," as does her identity scheme for premium wines from Sogrape Vinhos de Portugal, S.A.

DESIGNER DIRECTOR: Mary Lewis
DESIGNER: Mary Lewis
ILLUSTRATOR: Mary Lewis

Warm-hearted visual puns abound in Lewis Moberly's brand-identity scheme for Vinopolis, including a logotype, shopping bags, wine-bottle labels, and other printed materials. The design, of simple lines and basic colors, expresses both gastronomic pleasure and consumer-friendly sophistication.

DESIGN DIRECTOR: Mary Lewis
DESIGNERS: Nin Glaister, Mary Lewis, Ann Marshall
ILLUSTRATOR: Nin Glaister

PRINCIPALS: Paul White, Alistair Beattie, Ryan Jones, Nima Falatoori, Ian Wood, Tom Watt, Deseree Edwards
FOUNDED: 1985
NUMBER OF EMPLOYEES: 9

14 Apollo Studios
Charlton Kings Road
London NW5 2SA
TEL (44) 171-482-4262
FAX (44) 171-284-0402

Hip graphics, wacky comic-book fantasy, and the powerful tools of the digital revolution meet in the goofy-manic imaginations and on the frontier-stretching computer screens of Me Company's designers-illustrators. "Me Company is a name of an organization that wants to be a corporate personality," design-team member and principal Alistair Beattie jokingly observes. "We're all shouting, 'It's me'—but anonymously." As the studio's founding-year date suggests, and as its own promotional material advises, "From the beginning, Me Company has been harnessing digital technology" in the service of its artist-designers' "insatiable appetites for new and exciting digital imagery." That image-making is its specialty; using sophisticated computer programs, Me Company has created distinctive cartoon characters and stunning, surreal graphics that mix manipulated photos and original illustration for advertising and for music compact-disc packaging. The studio has produced memorable graphics that have captured the cyber-funk spirit of recordings by the Icelandic rock star Björk, and original cartoon figures for ad campaigns for Laforet, the ultra-cool fashion emporium in Tokyo. Naturally, Me Company has also left its mark on numerous music-related Web sites. Its illustration-based designs, which often incorporate unusual typefaces, appear to offer endless possibilities for expanded applications, most obviously in motion graphics or new media, and in film or video. "On-screen," a Me Company promo piece asserts, "you can be anything you want. Change your character. Have a visual presence in a physical incarnation."

ME COMPANY

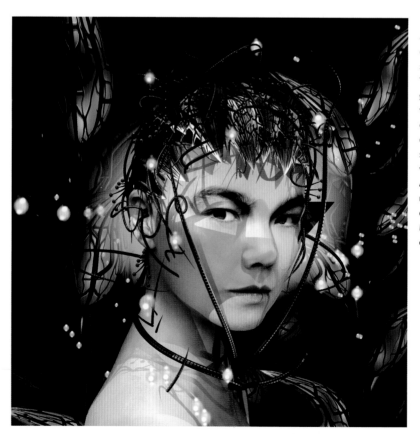

Me Company's artist-designers are obsessed with the ever-expanding power of today's sophisticated digital technology. They use it to make images and graphic-design compositions like these, for one of the Icelandic cyber-rocker Björk's compact discs, that prove, as they like to say, that "you can be anything you want."
ART DIRECTOR: Me Company
DESIGNER: Me Company
ORIGINAL PORTRAIT: Toby McFarlan Pond
CLIENT: One Little Indian 1998

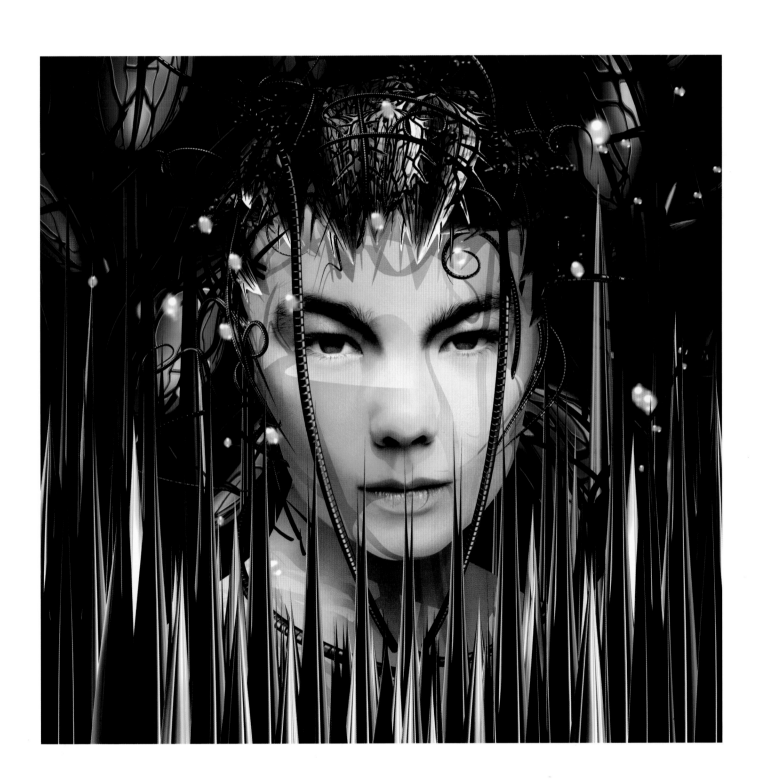

Me Company integrates type or logos and original, goofy-futuristic cartoon creations in compositions like these for Firetrap, a British fashion label.

ART DIRECTOR: Me Company
DESIGNER: Me Company
COPYWRITER: Me Company

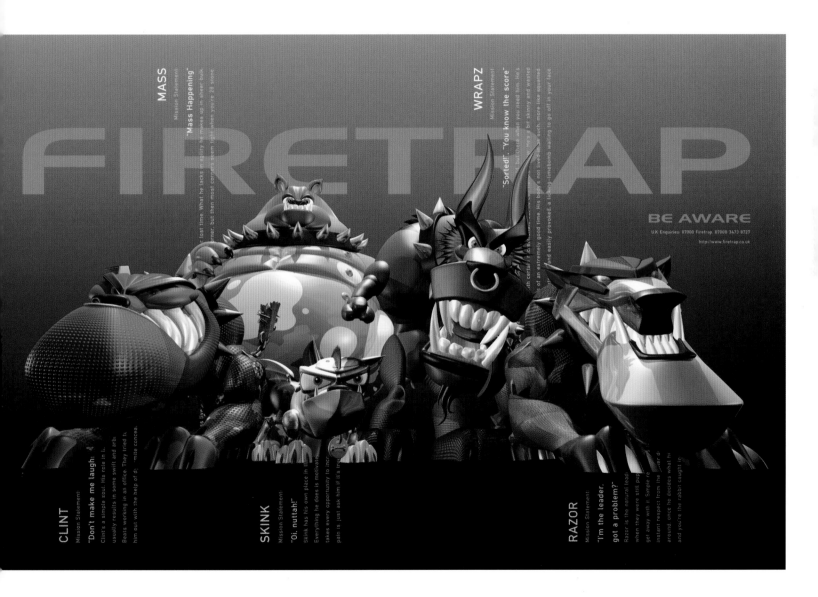

Me Company's artist-designers created these advertisements for the big sale events at Laforet, the super-hip retailer in Tokyo that caters to the style-devouring tastes of young Japanese fashion hounds.

ART DIRECTOR: Me Company
DESIGNER: Me Company
COPYWRITER: Me Company

LAFORET

12•12•97

LAFORET

GRAND BAZAAR

RETAIL THERAPY

Beam up a bargain

7/3 (Fri) - 7/7 (Tue)

LAFORET

GRAND BAZAR

PRINCIPALS: Anthony Michael,
Stephanie Nash
FOUNDED: 1985
NUMBER OF EMPLOYEES: 7

42-44 Newman Street
London W1P 3PA
TEL (44) 171-631-3370
FAX (44) 171-637-9629

Partners in and out of the studio, Anthony Michael and Stephanie Nash studied at Central Saint Martins College of Art and Design, the London school that has become one to watch for the innovative designers of all kinds that it has turned out in recent years. Nash worked for Island Records in the early 1980s and, with Michael, gradually established a studio. Known as masters of a clean, unfussy approach, their work can be as sleek and cool as it can be sumptuous and warm. This stylistic range—what one publication called a "neat-messy dichotomy"—encompasses everything from the duo's elegant, award-winning packaging for Harvey Nichols' high-end food products to its more collage-like, impulsive album covers for some rock-music acts. "We're used to doing things that are unconventional, not like you'd expect a piece of packaging to look," Nash has said. Also unusual, these days, is that Michael and Nash typically eschew the computer; they prefer to sketch by hand and to work closely with type suppliers, photo retouchers, and other collaborators to produce projects that exude hands-on perfectionism. Many of their assignments find them through a network of ever-circulating recommendations. "You don't have to do what was done before," Michael observes. The popularity of Michael-Nash's clever, well-crafted designs has proven the wisdom of that simple operating principle.

MICHAEL-NASH
ASSOCIATES

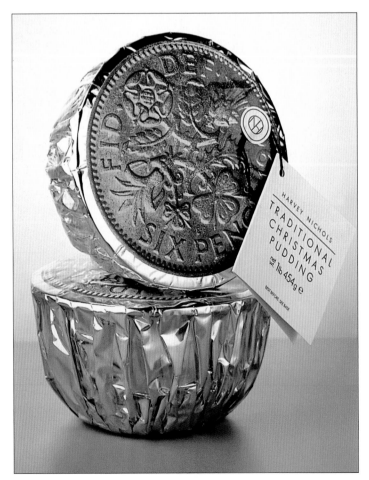

Michael-Nash Associates won a gold award from Design & Art Direction, Britain's leading organization of advertising and communications design professionals, for this wide-ranging packaging program for the department store Harvey Nichols' house brand of upscale food products. Using photography with a crisp, elegant touch, a hallmark of their work, Michael-Nash's unusual series of labels, boxes and bags appeal to the senses as much as to a sophisticated sense of style.
ART DIRECTORS: Stephanie Nash, Anthony Michael
DESIGNERS: Stephanie Nash, Anthony Michael

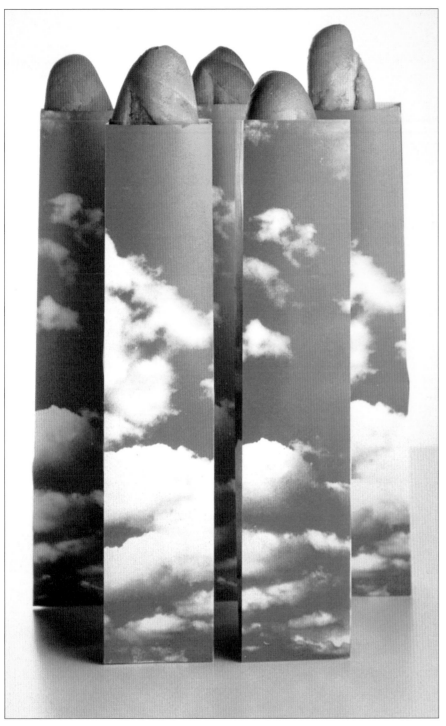

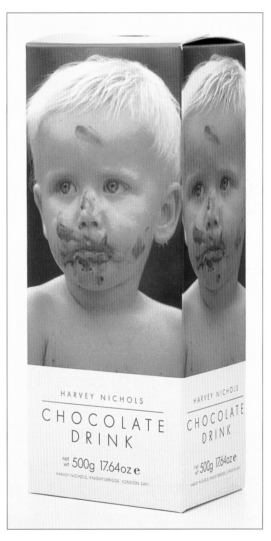

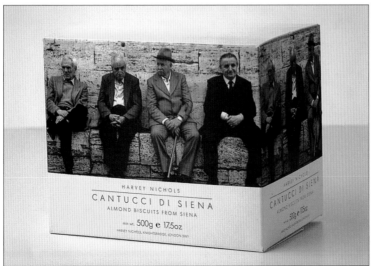

Michael-Nash Associates' sometimes slick, sometimes rough-edged design sensibility finds more impulsive, looser expression in many of its compact-disc and LP covers for rock-music and pop acts, as in this selection of album graphics for various record labels.
ART DIRECTORS: Stephanie Nash, Anthony Michael
PHOTOGRAPHER: Matthew Donaldson

FLUKE SIX WHEELS ON MY WAGO

ART DIRECTORS: Anthony Michael,
Stephanie Nash,
PHOTOGRAPHER: Julian Broad

THE BELOVED
X

ART DIRECTORS: Stephanie Nash,
Anthony Michael
PHOTOGRAPHER: Matthew
Donaldson

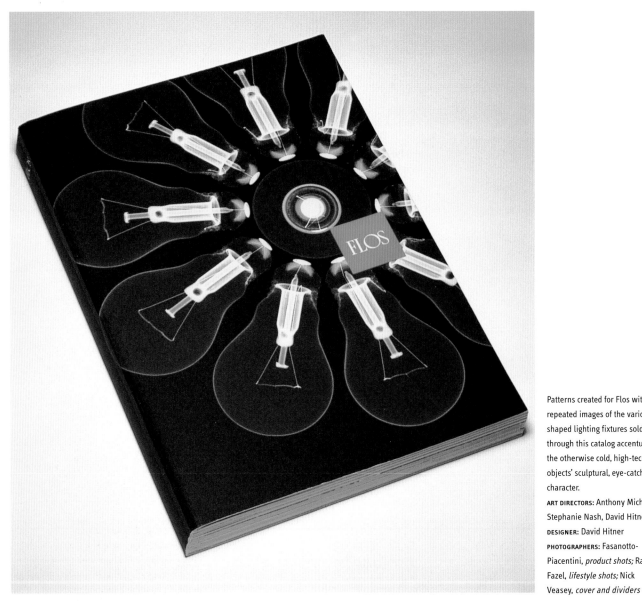

Patterns created for Flos with repeated images of the variously shaped lighting fixtures sold through this catalog accentuate the otherwise cold, high-tech objects' sculptural, eye-catching character.

ART DIRECTORS: Anthony Michael, Stephanie Nash, David Hitner

DESIGNER: David Hitner

PHOTOGRAPHERS: Fasanotto-Piacentini, *product shots;* Ramak Fazel, *lifestyle shots;* Nick Veasey, *cover and dividers*

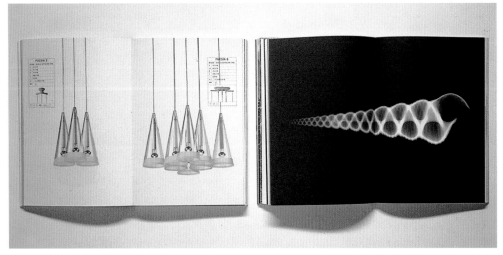

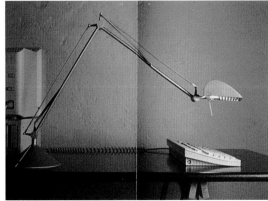

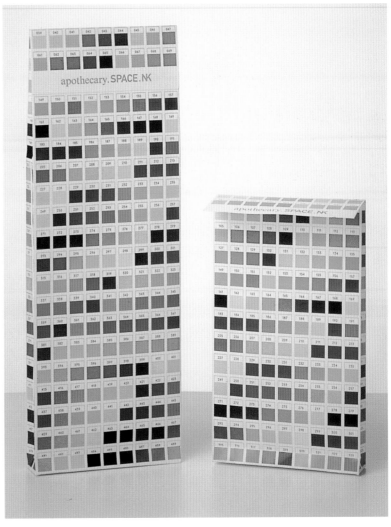

Printed color charts figure prominently in the designs of sleek retail packaging for Apothecary Space NK.

ART DIRECTORS: Stephanie Nash, Anthony Michael, David Hitner

DESIGNERS: David Hitner, Stephanie Nash

EXTRA VIRGIN TUNISIAN OLIVE OIL

FAMOUS SINCE ROMAN TIMES FOR IT'S CLEAN AIR AND WONDERFUL OLIVES, THE VILLAGE OF SALAKTA, NEAR MAHDIA ON THE MEDITERRANEAN COAST WAS NAMED FOR A ROMAN PRINCESS WHO RECOVERED HER HEALTH AND FOUND LOVE THERE. FOR TWENTY GENERATIONS, SAMI BAYOUDH'S FAMILY HAVE CAREFULLY PRESSED THE VILLAGE'S TINY SWEET OLIVES USING MARBLE MILLSTONES......
THIS GORGEOUS SOFT AND DELICATE OIL IS THE FIRST PRESSING OF THE NEW HARVEST - AS SAMI BAYOUDH SAYS: 'IT WILL RAVISH FRESH FISH AND SEDUCE YOUR SALADS! ENJOY IT WITH OUR LOVE!

The plain, nondescript, almost clinical look of a white-glass bottle of olive oil from a lesser-known Tunisian producer appears to ignore—indeed, to deny—branding. This denial only emphasizes the must-read attraction of its simple label, whose text explains the product's down-home origin.

ART DIRECTORS: Stephanie Nash, Anthony Michael, David Hitner

DESIGNERS: Kevin Gould, David Hitner

PRINCIPAL: Mitch

Unit 66
Pall Mall Deposit
124-128 Barlby Road
London W10 6BL
TEL (44) 181-968-1931
FAX (44) 181-968-1932

Have computer, will travel. A single name and a relatively transient existence suit Mitch just fine. A young designer who has worked with and assisted mentor Swifty of Swifty Typografix on numerous projects, and who has contributed to *Straight No Chaser,* the jazz magazine that has long been one of the senior designer's main concerns, Mitch also got his start in music-related graphics. Mitch studied at the University of Salford in the northwest; Swifty offered him a job after seeing an early version of Mitch's typeface called Fat Arse. Hand-distributed flyers are still a primary medium for getting the message out about events at London's popular clubs; in recent years, many of these eclectic, ephemeral, and surprisingly effective printed pieces, some no larger than bookmarks, have sailed out onto the music scene bearing Mitch's trippy, unpredictable designs and signature. He has allowed his name, treated logo-like in print, to become his personal brand identity, a not unclever marketing strategy and, for many creative types of Mitch's advertising-inured generation, a practice that comes naturally. Mitch's record-album and CD covers throb with the visual rhythms and ambiguous, sometimes digitally manipulated imagery that have become hallmarks of one of cutting-edge graphic design's now-recognizable modes. "I like to try things out and see what happens," this avid experimenter and quick style assimilator says. "Music-related jobs give me opportunities to introduce new ideas. I want to capture the spirit of the music or event I'm designing for, but also try to push the whole thing forward." Lately Mitch has turned his attention to motion graphics. "My aim is what I call corporate bombing," he says. "That's 'to bomb' meaning to be as prolific as possible, not like a graffiti artist, but in a corporate manner."

MITCH

What's in a name? For Mitch, a lot, because he uses only one and has treated it like a logo in print. It has become his personal brand identity, as effectively corporate and professional as it is spontaneous, like the graffiti-artists' signature "tags" that inspired it.

ART DIRECTOR: Mitch
DESIGNER: Mitch

GROOVE the

All Nations Under 'A Groove'

GROOVE the

DJs in rotation
Brian Norman
Maura Miller
Lyndon (Mr Resident)
Haitch
Scott Savonne (Music Power)
Dean Savonne (Kiss FM)
Misbehaviour
Lloyd (Boogie Boy)

EVERY FRIDAY at WKD 18 Kentish Town Rd. Opp. Camden Town Tube

FROM 9 - 3a.m Admission £5 After 10 PM

MUSICAL FLAVA SPANNING........RARE GROOVE/ UPFUNK/ 70s & 80s/ SOULFUL GARAGE

Live Elements supplied by What's That Noise Productions

For more information speak to Larrick on 0171 267 1869

Central to the evolution of Mitch's jazz-spirited, free-form style has been his work on numerous flyers and promotional printed pieces like these that advertise party nights and special events at music clubs.

ART DIRECTOR: Mitch
DESIGNER: Mitch

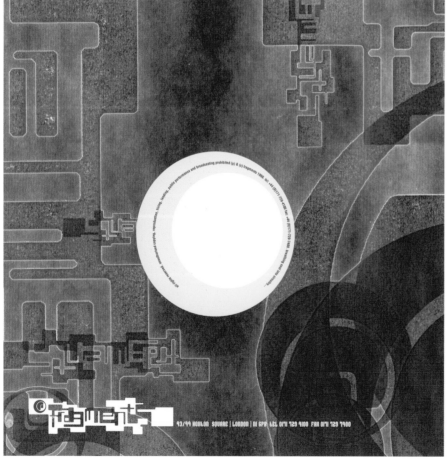

Mitch's label design, standard
sleeve, and sticker for Fragments
Records give an all-important,
cohesive look and feel to releases
issued on this British indie label.
ART DIRECTOR: Mitch
DESIGNER: Mitch

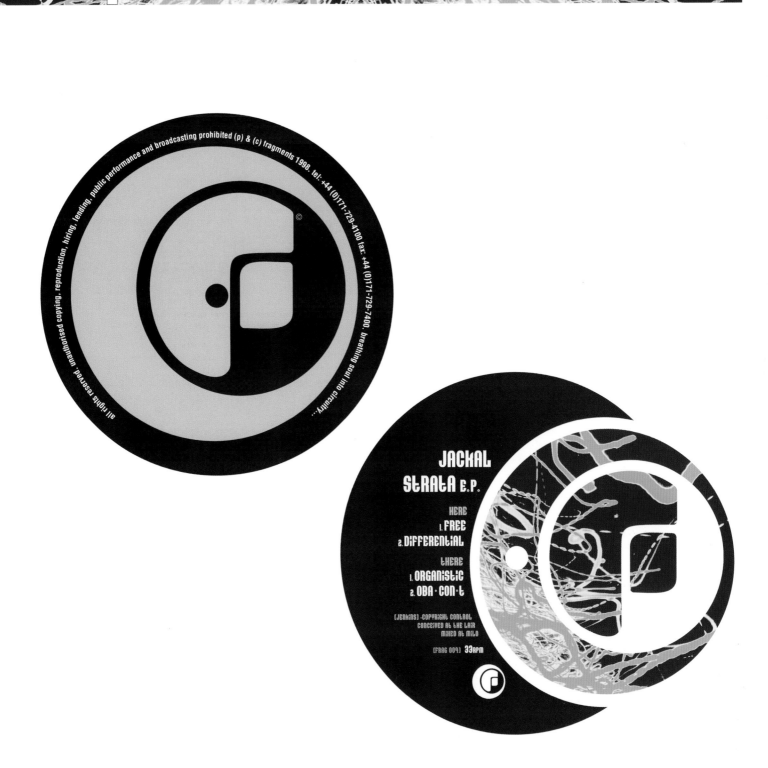

JACKAL
STRATA E.P.

HERE
1. FREE
2. DIFFERENTIAL

THERE
1. ORGANISTIC
2. OBA·CON·T

[JENKINS] -COPYRIGHT CONTROL
CONCEIVED AT THE LAIR
MIXED AT MILO

[FRAG 009] 33RPM

all rights reserved. unauthorised copying. reproduction. hiring. lending. public performance and broadcasting prohibited (p) & (c) fragments 1998. tel: +44 (0)171-729-4100 fax. +44 (0)171-729-7400. breathing soul into circuitry...

Ambiguous images are hallmarks of a lot of new, hip, music-inspired design, especially for record-album covers like these (and for compact discs, too). And in these postmodern times, anything visual is fodder for graphic designers' experiments. Here, allusions to movie posters can be detected in Mitch's choice and handling of type, and in his countdown numerals from film-reel leaders. These covers are for 12-inch vinyl records by Atmosfear (Disorient Recordings) and Red Snapper (Warp Records, Ltd.).

ART DIRECTOR: Mitch

DESIGNER: Mitch

PRINCIPALS: Aziz Cami, David Stuart, James
Beveridge, Gillian Thomas, Gareth Williams,
John Guy, Julia O'Mahony
FOUNDED: 1983
NUMBER OF EMPLOYEES: 65

Albion Courtyard
Greenhill Rents
Smithfield
London EC1M 6BN
TEL (44) 171-608-0051
FAX (44) 171-250-0473

Members of The Partners, one of London's largest design companies, have needed strong arms to haul in all the coveted awards the firm has won in recent years, including several for design effectiveness from the Design Business Association and others from Design & Art Direction, two of Britain's leading professional societies. Barclays, Harrods, J. Walter Thompson, Marks & Spencer, Warner Bros., and the NatWest Group are among the firm's clients, many of whom have remained with The Partners for a decade or longer. "We define and express what makes companies, their brands and their services different and special," The Partners' mission statement explains, recognizing that, as "markets, companies and technologies are all converging," it has become increasingly difficult to stand out in the corporate crowd. Thus, The Partners' work rests on a strategic, design-fueled approach to brand development: a combination of wit, good looks and practicality in visual-identity schemes that give character to corporate clients that need it or help corporate identities that need a boost in the marketplace. Examples of this creative range can be seen in the campaign for Barclays' b2, an all-new, personal-savings and investments service, or in the rejuvenation of the Decca record label's classical-music marketing. Despite its own considerably corporate size, The Partners still is known for innovating instead of relying exclusively on set formulas. A measure of its success is its clients' routine willingness to join the Partners' designers in taking creative risks.

THE PARTNERS

For many years, the Partners has designed posters and invitations for the Association of Photographers. Shown here: a tartan-patterned announcement of a show of Scottish and Irish images that, when torn off, reveals a poster for the next exhibition, about the male nude; a poster for a show of dog photos that plays with international directional symbols; and a poster that packs a visual palindrome: depending on which side is up, it depicts either a London or a New York skyline.
CREATIVE DIRECTOR: Gillian Thomas

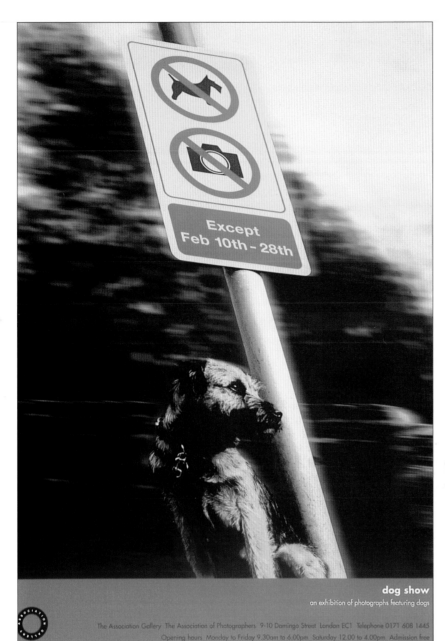

dog show
an exhibition of photographs featuring dogs

The Association Gallery The Association of Photographers 9-10 Domingo Street London EC1 Telephone 0171 608 1445
Opening hours Monday to Friday 9.30am to 6.00pm Saturday 12.00 to 4.00pm Admission free

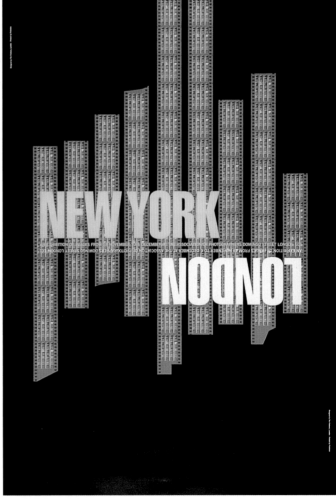

The Partners created a logo and visual-identity scheme for b2, Barclays' new company that offers personal-savings and investment services. The advertising agency Banks Hoggins O'Shea came up with the new outfit's name. With its logo and graphics, b2 seeks to communicate directly with potential customers and to cut through the usual communications mode of an industry sector known for drabness, jargon, and "fine print."

CREATIVE DIRECTOR: David Stuart
SENIOR DESIGNER: Tracy Avison
PROJECT MANAGER: Maryanne Murray

The Partners' designers regularly work with Warner Bros. to generate merchandising concepts that are later developed by the entertainment giant's in-house marketing-and-design team in Burbank, California. The Partners created this award-winning hoarding to mask renovation work on the building that houses the Warner Bros. Studio Store on Fifth Avenue in New York. The construction-site covering also served as a billboard to promote the Bugs Bunny-Michael Jordan movie *Space Jam*.

CREATIVE DIRECTOR: Greg Quinton
PARTNER IN CHARGE: Aziz Cami
PROJECT MANAGER: Samantha Argent

The Partners rejuvenated the Decca record label's marketing of classical music, traditionally a product category marked by dull, stuffy, lackluster graphics. First the designers revamped the label's logo, eliminating its white border and revising the proportions of its background, two-tone color field. Then they used the logo with crisp, stylish portrait photography in promotional posters. The background enlargement of musical scores balances, with a familiar, somewhat academic note, the contemporary star treatment of featured classical-music performers.

CREATIVE DIRECTOR: Aziz Cami
DESIGNER: Greg Quinton

Report & Accounts
1994-95

Members & Committees
1994-95

Annual Review
1994-95

City& Guilds

City & Guilds is a well-known British vocational organization that bestows awards. Its new logo, created by The Partners, dispenses with its old crest but ingeniously incorporates into a prominent ampersand the animal element of that heraldic symbol. **CREATIVE DIRECTOR:** James Beveridge

Thrislington Cubicles 1993

Thrislington, a British manufacturer of prefabricated toilet cubicles, has become the market leader in a sector not especially known for its creativity. Since 1984, The Partners has worked with Thrislington on visual-identity, brochure, direct-mail, and promotional-calendar projects. Its clever calendars have garnered 15 awards since 1993. Shown here: the 1993 week-at-a-glance design with each week printed on a swatch of newspaper that later can be used as toilet paper; the 1996 "Johns" calendar, its form inspired by traditional European Advent calendars, on which little doors open to show successive dates—but here, each opens to reveal a picture of a famous toilet; the 1995 calendar showing a generic, "ladies' loo" figure-symbol in an exotic location; and the 1994 calendar representing the days of the year with 365 penny-sized indentations for the days of the year.

CREATIVE DIRECTOR: Greg Quinton
PARTNER IN CHARGE: Aziz Cami

PRINCIPALS: Kenneth Grange,
David Hillman, Angus Hyland,
John McConnell, Justus Oehler,
John Rushworth, Daniel Weil
FOUNDED: 1972
NUMBER OF EMPLOYEES: 50

Pentagram Design, Ltd.
11 Needham Road
London W11 2RP
TEL (44) 171-229-3477
FAX (44) 171-727-9932

Founded by an industrial designer, an architect, and three graphic designers, Pentagram pioneered the development and implementation of a multidisciplinary approach to design problem solving. Within the company, which now has offices in London, New York, San Francisco, and Austin, Texas, each of 15 principals heads a creative team that functions like a separate unit, pursuing its own projects. But all of these teams serve clients' needs by drawing upon the entire organization's resources and expertise. Pentagram thus has become known for offering the resources of a large design-services provider while still delivering individual attention and avoiding the limitations of what it calls "small, one-dimensional boutiques." Pentagram's client list is as extensive and as studded with well-known corporate names as its history is long; an examination of the studio's portfolio is de rigueur in many design schools. At Pentagram, given its structure, there is, arguably, no one reigning house style. Nevertheless, from posters and book jackets to identity systems and interiors, classically modern principles of clean, uncluttered, well-ordered design and a visible awareness of the designer's power to shape the tone, looks, and content of visual communication are evident in every Pentagram project.

PENTAGRAM
DESIGN, LTD.

John McConnell designed *Waitrose Wine Direct Magazine* and related materials for a mail-order wine service. McConnell has served as design director of Boots, the national drugstore chain, since 1984, and he is advisor to the Royal Mail, Britain's postal service, on pictorial and commemorative stamp issues.

Waitrose Wine
Direct Magazine

Number 3 April 1997

Australia
comes of age

John Rushworth, who worked for the Conran Design Group before joining Pentagram, led the teams that developed these comprehensive identity and packaging schemes. For Tesco, the United Kingdom's leading supermarket retailer, Rushworth designed packaging and a carefully considered look for a new house brand that offers "a restaurant experience" in take-home food products. The design program achieves elegant understatement and suggests high quality through the use of simple geometric shapes and small, cropped, editorial-style photos. These elements enhance the brand's air of refinement. For The Berkeley, a Savoy Group hotel, Pentagram emphasized the establishment's distinct personality by using design to stress uniqueness over corporate branding.

Daniel Weil led the team that created and patented this new packaging for Superga, an Italian shoe manufacturer. These collapsible, reusable boxes, produced in Britain, are color-coded for casual or for sports shoes. Within each of these categories, they also are color-coded by seasonal type. The same geometry is used in boxes for a Superga line of inexpensive shoes; those containers do not have rubber tabs or press studs.

30 Canton Road
Tsimshatsui
Kowloon, Hong Kong

Tel: (852) 237 502 63
Fax: (852) 237 512 05

Renowned for his work from 1968
to 1975 as art director and deputy
editor of the innovative women's
magazine *Nova*, David Hillman
redesigned the *Guardian*
newspaper in 1989 and created
this identity system for Ez'ech,
a Hong Kong-based home-
accessories manufacturer, whose
current name comes from the
phonetic pronunciation of its
original name, SH. Chinese
people found it difficult to say,
so they pronounced it "ez-ech."

STAR ALLIANCE

Justus Oehler studied visual communication at the Fachhochschule in Munich. A design consultant to the World Economic Forum and to British publisher Faber & Faber, Oehler led the team that created an identity system for Star Alliance, a partnership of five airlines (Lufthansa, United Airlines, SAS, Thai Airways, and Air Canada). The star in the name and logo was chosen for its powerful symbolic value. The identity scheme was developed to hold its own in the visually cluttered environment of big, international airports and to have cross-cultural appeal and recognizability.

Through his own studio, Angus Hyland's work covered the book-publishing, fashion, music, and other industries before he joined Pentagram. He has taught at the London College of Printing and at the Royal College of Art. Hyland designed programs for performances at Shakespeare's Globe Theatre, a reconstruction project on which the late Theo Crosby (1926-1994), one of Pentagram's founders, worked for many years. For Canongate Books, Ltd., Hyland designed pocket-book editions of stories taken from the King James *Bible*. Typography and a graphic grid, both strong, along with sharp, black-and-white photography, hold the series together with a distinctive, unexpected look. Hyland designed the covers of Kafka's books for the British publisher Minerva.

PRINCIPALS: David Bradshaw, David Breen, Joseph Thomas
FOUNDED: 1994

Studio 1Q, Leroy House
436 Essex Road
London N1 3QP
TEL (44) 171-704-9624
FAX (44) 171-704-9623

Push is a small studio whose founding triumvirate of designers shares a common background in communication-design studies at the University of West England and at Central Saint Martins College of Art and Design. The latter, well-known London school recently has earned a reputation as a breeding ground for especially imaginative, energetic young talent; like David Bradshaw, David Breen, and Joseph Thomas of Push, many of its graduates go right into business on their own soon or immediately after picking up their degrees. Push's members have said that they did not set up a design company "to make money," but rather "to be able to make our own choices." Apparently favoring a good degree of self-expression within the parameters of each project's specific brief, Push, like other small, independent-minded studios, can be hard to pin down in terms of overall, prevailing styles or strategies in its diverse portfolio. Instead, experimentation and a loose, abstract-illustrative character mark many of Bradshaw, Breen, and Thomas's designs, which bob and swim with free-floating blocks of color or lines of display type (which may be hand-drawn). Sometimes, photo images mix it up with line drawings; usually, no obvious grid or other organizing structure is at work in Push's poster, postcard or other designs, nothing that could strictly limit the sense of spontaneity and bounce that are the mainstays of this studio's formula-avoiding compositions.

PUSH

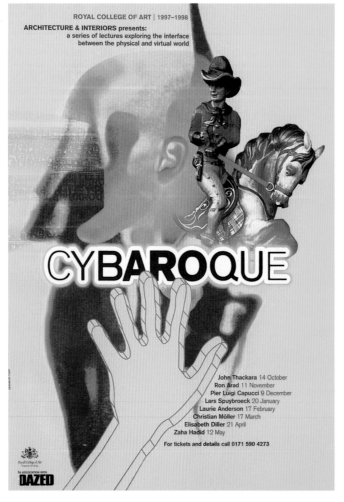

Photo imagery and line drawing come together in a poster that advertises a series of lectures at the Royal College of Art.
ART DIRECTION: Push
DESIGN: Push

Rather than using conventional pictorial imagery, Push's poster for a jazz performance evokes the excitement of a live, outdoor concert.

ART DIRECTION: Push

DESIGN: Push

DESIGN BY PUSH 0171 704 9624

YOUNG BLOODS JAZZ SESSIONS

The French Connection

Saxophone **Friday 3 April at 8pm** **Stéphane Spira Jazz Quartet** £6 (£4 cons)
Guitar **Sunday 10 May at 8pm** **Jean-Pierre Llabador Quintet** £6 (£4 cons)
Piano **Saturday 6 June at 8pm** **Bobby Few Trio** £7 (£5 cons)

Croydon Clocktower Katharine Street, Croydon Box Office 0181 253 1030
Nearest Station: East Croydon, 15 minutes from Victoria—honest!

LONDON ARTS BOARD

SEPTEMBER TO NOVEMBER 1997
SATURDAY 20TH SEPTEMBER AT 8PM **BYRON WALLEN'S EARTH ROOTS**
FRIDAY 3RD OCTOBER AT 8PM **BEAT DIS FEATURING BRIAN EDWARDS**
FRIDAY 24TH OCTOBER AT 8PM **ORPHY ROBINSON'S CREATIVE FORCE**
SATURDAY 29TH NOVEMBER AT 8PM **DAVID JEAN-BAPTISTE**

CROYDON CLOCKTOWER, KATHARINE STREET, CROYDON
BOOK TICKETS ON 0181 253 1030
NEAREST STATIONS: EAST & WEST CROYDON
DEAD EASY TO GET TO

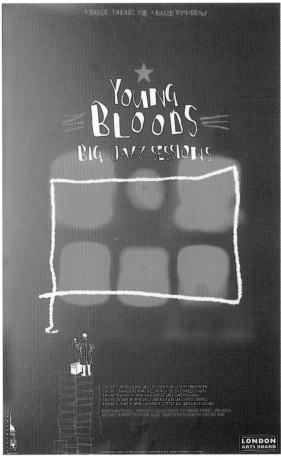

Illustration, hand-drawn lettering,
a sometimes limited color
palette, and free-floating headlines
are some of the elements that
energize Push's posters for a
series of jazz concerts.

ART DIRECTION: Push

DESIGN: Push

Push's own promotional material includes a colorful, illustrated poster and a series of postcards, some of which reprise the studio's poster designs for various clients.

ART DIRECTION: Push

DESIGN: Push

you
have a right
to safer sex,
your
life
could
depend
on it

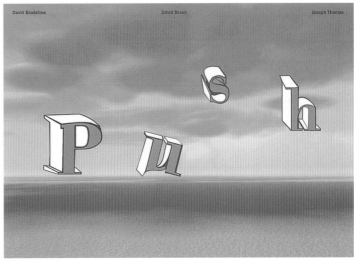

David Bradshaw David Breen Joseph Thomas

For film & video makers who live, work or study in the London Borough of Croydon.
Phone Croydon Clocktower on 0181 253 1030

Radiating lines allude to the magnetic allure of awards in this poster that calls for submissions from film- and video-makers to a popular contest.

ART DIRECTION: Push

DESIGN: Push

★ ★ ★ ★ ★ ★ ★ ★

>WHO ATE ALL THE PIES? was designed by EMAP Radio as a sophisticated, in-depth sports magazine programme, its aim to scrutinise, analyse and soberly reflect on all aspects of Premiership football. So what went wrong? At the time of writing, it is, in contrast, an asinine, juvenile, vicious, scurrilous and distasteful outpouring of bile and a lame imitation of humour... appealing only to the lowest common denominator, the worst kind of football fan. People like... well, like me and you. And three quarters of a million radio listeners every Saturday afternoon.

>MAD, BAD, DANGEROUS TO KNOW, CYNICAL, CRUEL AND UNDERHAND. HANG ABOUT, THAT'S DENNIS WISE.

>WHO ATE ALL THE PIES? IT'S NOT BIG, IT'S NOT CLEVER, BUT IT'S ON EVERY SATURDAY LUNCHTIME AND IT'S FUNNY AS HELL.

>SO WHAT IS IT?

Well, the basic premise is to take everything that people hold dear about the game, mash it up, reheat it and force-feed it back to them in six greasy gristly portions. In POT SHOTS, we launch a gratuitous attack on some player, manager, official, ball-boy or club mascot who has unwittingly been incurring our wrath of late... in THE BACK PASS, we exploit the unfair advantage of hindsight to launch gratuitous attacks and harangue teams and players for their performances on and off the field over the previous seven days... in GAME DAY NOTES AND QUOTES, we harangue, launch gratuitous attacks and snipe at the things we think they're going to do over the course of the afternoon. In THE PLAYER'S PROFILE, we take respected professional footballers — and Peter Schmeichel, Steve McManaman, and David Kelly — put them on the spot and try and uncover things we can use to harangue, snipe and launch gratuitous attacks on them about in later shows. Whilst, marking something of a departure for the programme, THE DAY OF THE MATCH creates fictional scenarios, loosely based on real people and events, and through them launches gratuitous attacks, harangues, snipes and ridicules professional footballers, managers and teams. In THE BIG MATCH CLASH, we let the fans do it for us.

emap on air

This exuberantly colorful information kit for Emap On Air aims to promote a series of radio programs about the world of European football (soccer) and to attract advertisers to buy time around them.
ART DIRECTION: Push
DESIGN: Push

PRINCIPALS: Richard Bonner-Morgan

Floor 2
1 Tysoe Street
London EC1R 4SA
TEL (44) 171-837-8575
FAX (44) 171-837-8576

When it comes to studio configurations, Richard Bonner-Morgan, who represents London's ever-present breed of peripatetic, independent graphic designers, probably has seen and worked in them all. A decade ago, Bonner-Morgan earned his master's degree in the well-known post-graduate program at the Royal College of Art, where he now teaches; after completing those studies, he worked for *i-D* magazine and at various studios. Later, with two collaborators, he co-founded NICE Design, a collective of independent designers. Their assignments included layouts for magazines and graphics for Levi-Strauss and the music industry. "We were always very manual in our design techniques," Bonner-Morgan recalls. "We did everything ourselves." His modus operandi, he says, was "Guesswork = risk = fun." After five years with NICE, Bonner-Morgan set off completely on his own. In recent years, he has been closely associated with Heart, one of Britain's top agencies for illustrators, whose founder, Darrel Rees, tapped Bonner-Morgan to create the company's visual-identity program and promotional materials in 1993.

Bonner-Morgan's print ads, posters, cards, and inventive, spiral-bound promo booklets have provided eye-catching vehicles for Rees to get the word out about the range of artists and illustration styles that Heart represents. Bonner-Morgan has also enjoyed a long association with Film and Video Umbrella, a group that organizes touring film and video presentations; a master of the art of stretching tight production budgets, he has devised countless folded-poster programs, brochures, and booklets that capture the moods of these series' often unusual, avant-garde offerings. In these works, carefully considered two-color palettes and paper choices yield rich, luminous results. "I'm always looking to make something that's practical, striking and, above all, economical," Bonner-Morgan notes. Today, he sometimes works on projects with other design studios.

RICHARD BONNER-MORGAN

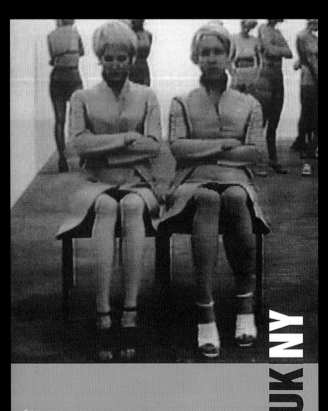

This staple-bound program for *UK/NY*, a Film and Video Umbrella series of works from the United Kingdom and from New York, has two "front" covers. The cover for one half of the booklet opens onto a list of featured British works; flipped upside-down, the second cover, for the other half, opens onto a list of New York works.
DESIGNER: Richard Bonner-Morgan

UK|NY

a film and video umbrella touring programme

On each of the three large screens that make up her projection piece 'Slips', Katharina Wibmer wears a variation of the same furtive and suspicious expression; directed, it would seem, at the two unwelcome alter egos who have muscled in on her personal space. Her mood does not improve when one of the doppelgangers abruptly shifts position, the jerky, involuntary movement having a slapstick knock-on effect on the others. Nor do things pick up when, at last walking freely from screen to screen, she stumbles repeatedly over the same unseen obstacle. This is nothing, however, compared to having the ground on which she is standing lurch violently beneath her, causing her to fall, eyes wide and arms flapping, out of frame. Time and again, Wibmer and her mirror images right themselves, only for the same thing to happen. Like a novice on the ice, or a child trapped in a nightmare nursery rhyme, they haul themselves to their feet, only for the bottom to fall out of their world once again.

Wibmer may enjoy acting the comic fall-girl in her own playfully unruly universe, but she and her long-time collaborator, cameraman and dramaturgist Joachim Fleischer, are most definitely in control. As is the case with all apparently casual, knockabout humour, each individual pratfall is meticulously worked out, so as to sustain the illusion that something other than sleight-of-hand with the camera is responsible for the sudden, seismic events which rock this looking-glass world on its axis. The clever manipulation of space and perspective and the stark silhouetting of figure and background, deriving as much from Fleischer's grounding in experimental film as Wibmer's long-standing interests in physical theatre and puppet animation, lend a surreal, almost fairground quality to the work. Looking at the three-screen *tableaux vivant* of 'Slips', one is reminded of the art-historical form of the triptych, of course, but just as forcefully of a hall of mirrors, a penny arcade, a shooting gallery (with Wibmer as a kind of human skittle), even of the scrolling windows of a fruit machine.

Allusions to the magic and spectacle of the fairground and to a history of pre-cinematic optical entertainments are a common feature of many of the works that Wibmer and Fleischer have made together. An early video tape 'Franzi', for instance, is almost a conceptual art update on that old illusionist staple involving a body and box. On this occasion, the box is a television monitor, which the body in question (Wibmer's) amusingly struggles to escape from; banging her head against the boundaries of the screen or, when an involuntary action (a cough, a sneeze) causes her to move, falling out of frame altogether. (The installation version of this piece, extended over three separate monitors, develops the idea further and rehearses many of the spatial tricks that later occur in 'Slips'). In another video, 'Die Letzte Lockerung' ('The Ultimate Relaxation'), Wibmer plays with the image of her body in a distorting lens like a child in front of a funhouse mirror. Much of the charm of the tape lies, again, in the extremely subtle and precise way she employs the lens' optical 'hot-spot': grotesquely contorting her legs and belly, exaggeratedly flexing a muscle or magnifying a facial expression.

In much the same way, Wibmer and Fleischer's work as a whole adds an intriguing twist to a contemporary preoccupation with the body in an age not so much of mechanical reproduction as increasing digital replication. Eschewing futuristic speculation about the extent to which the body is becoming mediated by technology, Wibmer and Fleischer offer a deft and disarming meditation on gesture, behaviour and identity that, for all its apparent innocence and naiveté, retains a compelling and provocative edge. Using humour as its own distorting mirror, they reflect back an image of ourselves which, in its all-too-human quirks and fallibilities, is instantly recognisable and strangely affecting. Deadpan, droll and quietly infectious, 'Slips' is a sure-footed step forward for their unsettling and ambivalent art.
Steven Bode

For a Film and Video Umbrella series of video works by different artists, Bonner-Morgan devised a series of five three-panel brochures with coordinated covers. One describes the complete series; each featured artist is covered in his or her own brochure as well.
DESIGNER: Richard Bonner-Morgan

a film and video umbrella

Gary Hill

an index of
possibilities
**a selective video
retrospective**

Chopped-up, backward and
overlapping letters energize
Bonner-Morgan's folded-poster,
Gary Hill program brochure for
Film and Video Umbrella.
DESIGNER: Richard Bonner-Morgan
for NICE

Bonner-Morgan has produced graphics for Film and Video Umbrella's traveling presentations of experimental film and video works. His folded-poster program brochures for these series vary in looks from the abstract to the expressionistic, reflecting the moods of their avant-garde offerings.

DESIGNERS: Kate Tregoning and Richard Bonner-Morgan for NICE

a film and video umbrella TOURING PROGRAMME

AT THE EDGE OF THE WORLD

DESIGNER: Richard Bonner-Morgan

to camera

a film and video umbrella TOURING PROGRAMME

DESIGNERS: Kate Tregoning and
Richard Bonner-Morgan for NICE

electricdance

a film and video umbrella touring programme
in association with Northern:Electric:Dance

Careful color choices in Bonner-Morgan's limited-palette, low-cost print projects yield dramatic results. In this folded-poster, Film and Video Umbrella program brochure, plain black and pea-soup green overprint to produce a warm, dark shade of brown.
DESIGNER: Richard Bonner-Morgan

Making clever use of a single large sheet printed on both sides, and avoiding any unnecessary waste, Bonner-Morgan designed this booklet for Film and Video Umbrella made up of smaller sheets that were cut and staple-bound.
DESIGNER: Richard Bonner-Morgan

Each new edition of Bonner-Morgan's promo booklet for Heart engenders its own related, design-coordinated campaign that encompasses posters or advertisements for trade magazines. Ironically, he notes, his ad designs for this illustration agency normally do not feature member artists' illustrations.
DESIGNER: Richard Bonner-Morgan

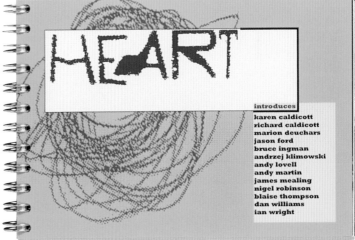

PRINCIPALS: Robbie Bear

31 Birch House
Droop Street
London W10 4EQ
TEL (44) 181-964-9820
FAX (44) 181-968-1932

A painter's touch and a preoccupation with the subtle language of texture that can be as poetic, evocative or exciting as decorative type or bold images are never far removed from Robbie Bear's designs of music-related flyers, magazine pages, and logos. A young designer who has worked alongside of and for Swifty of Swifty Typografix, and who has soaked up something of this influential expert's passion for no-holds-barred experimentation, Robbie Bear works in a mode at once quick in impulse and long on craftsmanship. When he develops the layout of a flyer or poster, he may elaborate, enlarge or reconfigure a motif that begins as a doodle. When he creates a logotype design, he may start with simple sketches, ultimately using the computer to shape and refine its final form, and often retaining refreshing, recognizable hints of its brushy or spray-painted origins. The result is a concentrated, combined shot of energy and visual texture that contrasts with and enlivens the otherwise slick, cool feeling of most computer-generated design. "I use a lot of my paintings and abstract sketches as backgrounds in my designs," Robbie Bear explains. "That's one way I manage to sneak in the arty, painterly thing, but everything gets fully integrated, too." At its best, Robbie Bear's work communicates with the cool-warm, steady buzz that echoes its favorite jazz-music inspirations, punctuated by the sputtering jolts of a bold, hand-drawn headline here or the honky-tonk rumble of a colorful pattern there (as in his All Stars flyer for The Beat Bar).

ROBBIE BEAR

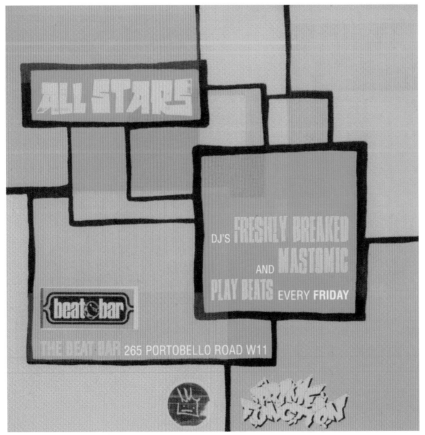

Robbie Bear is a collector-creator of visual textures—many of which emerge from his paintings—that he recycles or incorporates into his graphic-design work. Similarly, sketches or doodles of patterns may evolve into strong motifs in his layouts, as in these flyers for music-club events.

ART DIRECTOR: Robbie Bear
DESIGNER: Robbie Bear

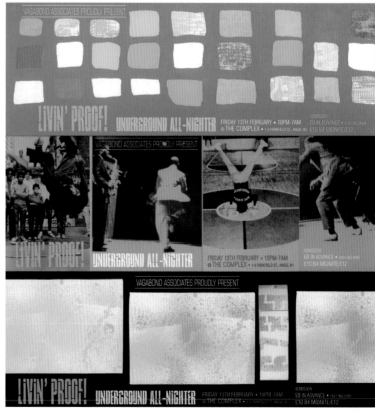

underground radio

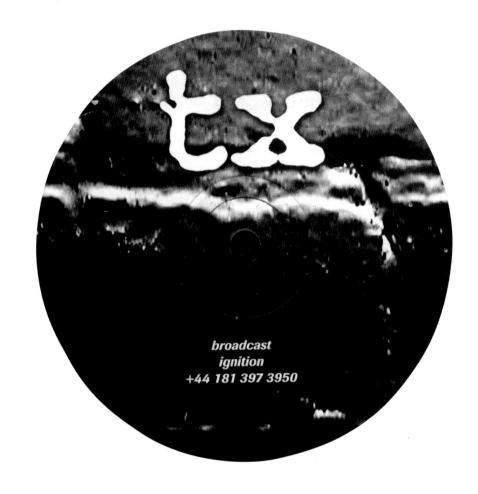

broadcast
ignition
+44 181 397 3950

Robbie Bear's logos for places, events, and institutions that are part of London's vibrant music scene, like these for an underground radio station and a popular club, may be hand-drawn or put through the ringer of photocopying and computer manipulation. Some may derive from brushy or spray-painted sketches, like his atom symbol for J-wave, a Japanese client.

ART DIRECTOR: Robbie Bear
DESIGNER: Robbie Bear

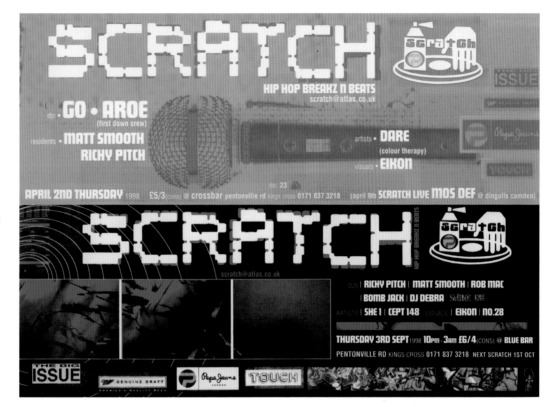

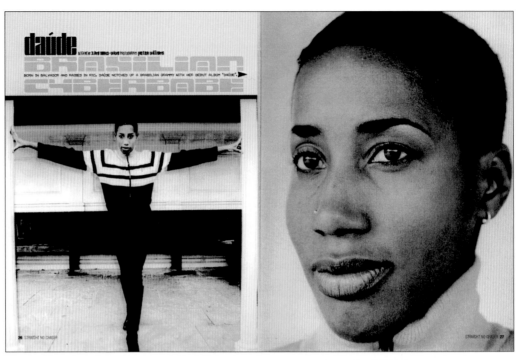

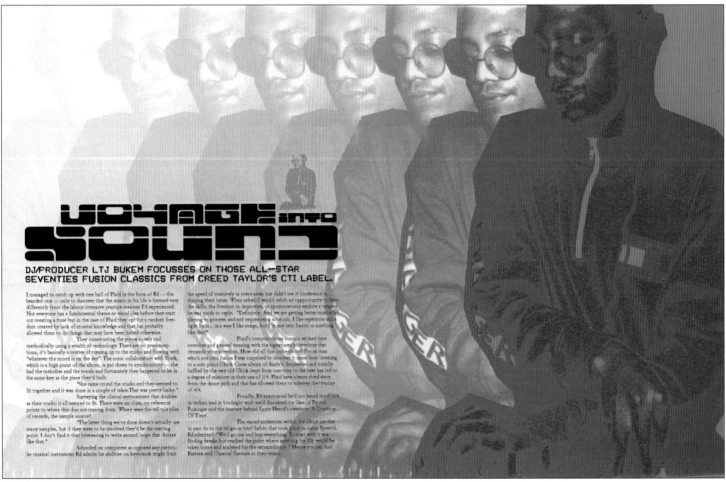

VOYAGE INTO SOUND

DJ/PRODUCER LTJ BUKEM FOCUSSES ON THOSE ALL-STAR SEVENTIES FUSION CLASSICS FROM CREED TAYLOR'S CTI LABEL.

I managed to catch up with one half of Plaid in the form of Ed — the bearded one — only to discover that the music in his life is formed very differently from the labour intensive practice sessions I'd experienced. Not everyone has a fundamental theme or visual idea before they start out creating a tune but in the case of Plaid they opt for a random freedom created by lack of musical knowledge and that has probably allowed them to do things that may have been halted otherwise.

They constructing the pieces slowly and methodically using a wealth of technology. There are no preconceptions, it's basically a matter of turning up to the studio and flowing with "whatever the mood is on the day". The sonic collaboration with Björk, which is a high point of the album, is put down to synchronicity — she had the melodies and the vocals and fortunately they happened to be in the same key as the piece they'd built.

"She came round the studio and they seemed to fit together and it was done in a couple of takes. That was pretty lucky."

Surveying the clinical environment that doubles as their studio it all seemed to fit. There were no clues, no reference points to where this duo are coming from. Where were the tell tale piles of records, the sample source?

"The latest thing we've done doesn't actually use many samples, but if they were to be involved they'd be the starting point. I don't find it that interesting to write around loops that dictate like that."

Schooled on computers as opposed any particular musical instrument Ed admits his abilities on keyboards might limit the speed of creatively in some areas but didn't see it hinderance in shaping their tunes. When asked if would relish an opportunity to have the skills, the freedom to improvise, to spontaneously explore a tangent he was quick to reply. "Definitely. And we are getting better musically, playing to grooves and not sequencing so much. I like repetition and a tight form... in a way I like songs, but I'm not into fusion or anything like that."

Plaid's compositions contain wicked time-stretches and general messing with the signatures/polyrhythms that demands your attention. How did all this come about? For an man who's not into fusion I was surprised to discover it came from listening to a solo piano Chick Corea album of Andy's. Impressed and initially baffled by the way old Chick leapt from one tune to the next has led to a degree of mimicry in their use of 3/4. Plaid have always shied away from the dance path and that has allowed them to sidestep the tyranny of 4/4.

Proudly, Ed announced he'd not heard much 3/4 in techno and in hindsight wish we'd discussed the likes of Pete's Pulsinger and the mastery behind Larry Heard's awesome 'A Question Of Time'.

The varied ambiences within the album are due in part to the religious vinyl habits that took place in sunny Ipswich. Ed admitted; "We'd go out and buy everything. To start with it was finding breaks but reached the point where anything for 20p would be taken home and analysed for the extraordinary." Hence you can find Eastern and Classical flavours in their music.

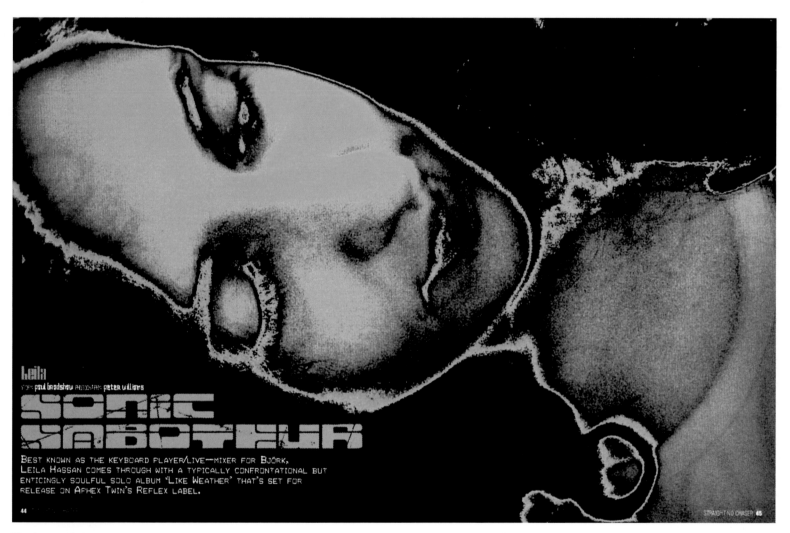

leila
STORY: **paul bradshaw** PHOTOGRAPHY: **peter williams**

SONIC SABOTEUR

BEST KNOWN AS THE KEYBOARD PLAYER/LIVE—MIXER FOR BJÖRK,
LEILA HASSAN COMES THROUGH WITH A TYPICALLY CONFRONTATIONAL BUT
ENTICINGLY SOULFUL SOLO ALBUM 'LIKE WEATHER' THAT'S SET FOR
RELEASE ON APHEX TWIN'S REFLEX LABEL.

44

STRAIGHT NO CHASER 45

Like other young designers
who have worked with Swifty
Typografix, Robbie Bear has
created layouts for the jazz
magazine *Straight No Chaser*,
whose art direction Swifty
oversees.

ART DIRECTOR: Robbie Bear
DESIGNER: Robbie Bear

PRINCIPALS: Morag Myerscough,
Gavin Ambrose, Chris Merrick,
Roanne Bell, Joe Kerr, Ishbel
Myerscough
FOUNDED: 1993

30 D Great Sutton Street
London EC1V 0DU
TEL (44) 171-689-0808
FAX (44) 171-689-0909

In the decade since Morag Myerscough graduated from the Royal College of Art, her substantial body of work has amplified classic modernist principles while simultaneously echoing the assertive, sometimes self-conscious aesthetic that has characterized much design of the 1990s. But Myerscough consistently has cut through the gimmickry and aching cleverness of the styles of the times; clarity and boldness anchor her work. Myerscough first made a name for herself as a senior designer at Lamb & Shirley before going solo in 1990. In Milan, she helped establish a new design direction for Michele de Lucchi's design department. Since 1989, she has taught at London's Central Saint Martins College of Art and Design. She has also served as graphic-design consultant to the Conran Design Partnership. An air of unbridled spontaneity, in which design solutions mirror Myerscough's penchant for bright, clear, declarative elements, fills her studio. But this air belies the diligent research and reworking that drive each project. "Often we have a strong sense of where we want to go with a design; it's just a matter of figuring out how to get there," Myerscough observes. "Also, I like to experiment with new formats, like the folded poster-as-catalogue for wireworks or the folded poster-as-magazine for Bluebird." Then there's the fluke success. Myerscough recalls with a laugh: "Our simple business card for Joe Kerr, featuring nothing more than street graffiti with the spray-painted name 'Joe,' won a top award. Who would have guessed?"

STUDIO MYERSCOUGH

I LOVE THE REST OF MY LIFE
THOUGH IT IS TRANSITORY
LIKE A LIGHT AZURE MORNING GLORY.

ACTIVATE
THE
BODY'S
POWERS

SYMBOL OF LIFE

Studio Myerscough often works closely with architects when creating a client's visual identity, and undertakes many interior design projects in conjunction with its graphic-design work. This studio has explored the potential of the folded poster or broadsheet as a magazine. Its promotional materials for the Broadgate Club West, a London health club, take advantage of such large formats. Their look exemplifies Morag Myerscough's penchant for bold, assertive, clear elements in simple, powerfully composed layouts.

Main promo piece:
ORIGINAL CONCEPT: Morag Myerscough, Eugenie Biddle, Joe Kerr
DESIGNERS: Morag Myerscough, Chris Merrick
PHOTOGRAPHERS: John Hicks, Richard Learoyd, Fleur Olby, Alan Crockford, Hans Silvester, Edward Sykes
COMPUTER IMAGES: Sham
ARCHITECTURAL TEXT: Joe Kerr

Newletter, edition 1.2:
DESIGNER: Morag Myerscough
PHOTOGRAPHERS: John Hicks, Richard Learoyd, Fleur Olby
COMPUTER IMAGES: Sham
ARCHITECTURAL TEXT: Joe Kerr

Newsletter, edition 1.3:
credits same as above, plus
PHOTOGRAPHER: Edward Sykes

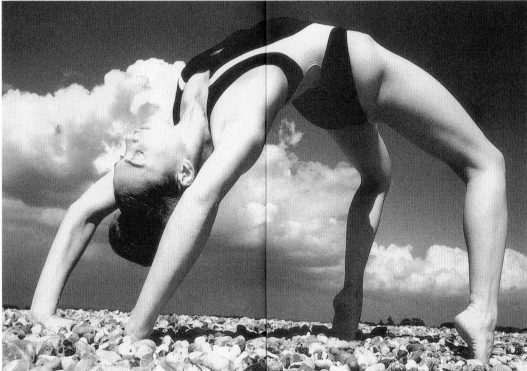

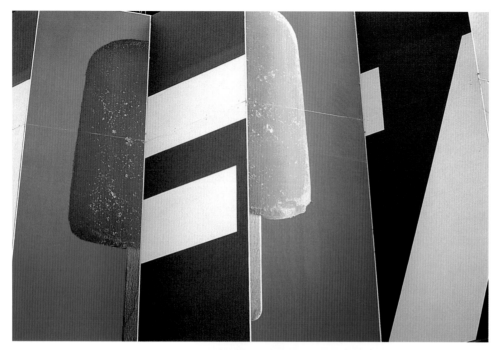

Studio Myerscough brings so-called environmental or super graphics into the late nineties with the festive colors and exuberant visual rhythms of this construction-site hoarding for a London building under development by The British Land Company.

DESIGNERS: Studio Myerscough/Allford Hall Monaghan Morris Architects

PHOTOGRAPHER: Trevor Key

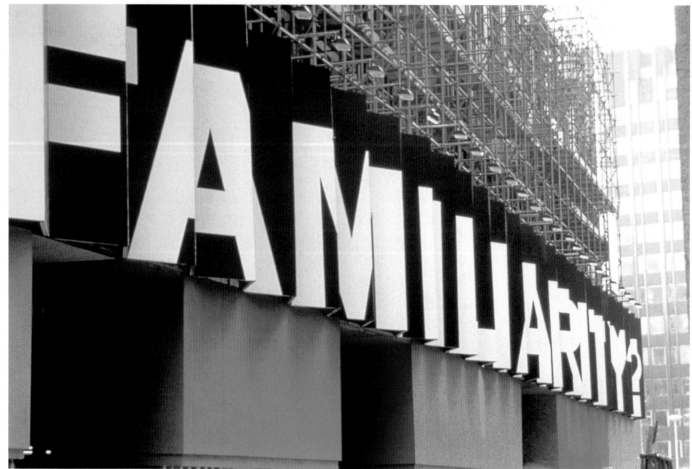

BLUEBIRD
THE KING'S ROAD GASTRODROME

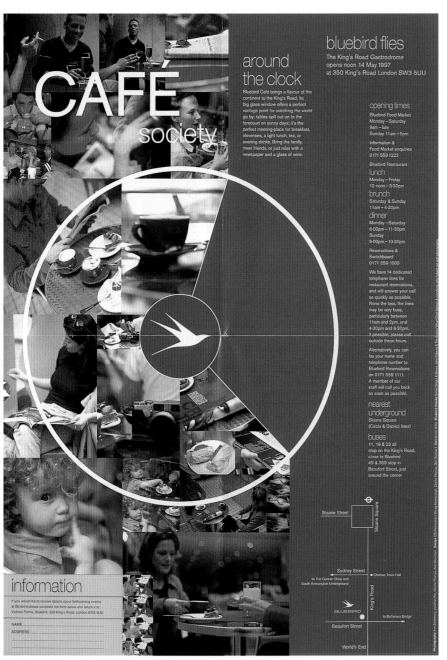

CAFÉ society

around the clock

Bluebird Café brings a flavour of the continent to the King's Road. Its big glass window offers a perfect vantage point for watching the world go by; tables spill out on to the forecourt on sunny days; it's the perfect meeting-place for breakfast, elevenses, a light lunch, tea, or evening drinks. Bring the family, meet friends, or just relax with a newspaper and a glass of wine.

bluebird flies

The King's Road Gastrodrome opens noon 14 May 1997 at 350 King's Road London SW3 5UU

opening times

Bluebird Food Market
Monday – Saturday
9am – late
Sunday 11am – 5pm

Information &
Food Market enquiries
0171 559 1222

Bluebird Restaurant

lunch
Monday – Friday
12 noon – 3-30pm

brunch
Saturday & Sunday
11am – 4-30pm

dinner
Monday – Saturday
6-00pm – 11-30pm
Sunday
6-00pm – 10-30pm

Reservations &
Switchboard
0171 559 1000

We have 14 dedicated telephone lines for restaurant reservations, and will answer your call as quickly as possible. None the less, the lines may be very busy, particularly between 11am and 2pm, and 4-30pm and 6-30pm. If possible, please call outside these hours.

Alternatively, you can fax your name and telephone number to Bluebird Reservations on 0171 559 1111. A member of our staff will call you back as soon as possible.

nearest underground
Sloane Square
(Circle & District lines)

buses
11, 19 & 22 all stop on the King's Road, close to Bluebird
49 & 359 stop in Beaufort Street, just around the corner

Sloane Street

Sloane Square

Sydney Street
to The Conran Shop and
South Kensington Underground

Chelsea Town Hall

King's Road

BLUEBIRD

to Battersea Bridge

Beaufort Street

World's End

information

If you would like to receive details about forthcoming events at Bluebird please complete the form below and return it to: Victoria Patnla, Bluebird, 350 King's Road, London SW3 5UU

NAME

ADDRESS

Opened in 1997, Bluebird is design impresario Sir Terence Conran's stunning transformation of a historic, former garage building into London's most attractive and multifaceted food market. Morag Myerscough created the logo and graphics for the self-styled "gastrodome" located in chic King's Road, including a promotional magazine in the form of a folded poster, whose many sides and spreads provide ample room for announcing Bluebird's products and services. The novel format also echoes the enterprise's expansive, ambitious scope.

DESIGN: CD Partnership with Morag Myerscough

DESIGNERS: Morag Myerscough, Charlie Thomas, Dan Thomas

PHOTOGRAPHERS: Ann Söderberg, *main photographer*, Charlie Thomas, Jonathan Pile, Alan Newnham

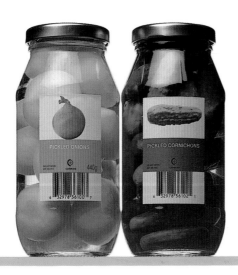

The simple boldness and emphatic clarity that are hallmarks of Studio Myerscough's work vividly shape this color-rich packaging scheme for an upscale line of food products marketed by the Conran Design Partnership, for which Morag Myerscough has served as graphic-design consultant. Headed by Sir Terence Conran, the company operates the well-known Conran home-furnishings stores in the United Kingdom and operates numerous design pace-setting restaurants.

DESIGN: CD Partnership with Morag Myerscough
DESIGNERS: Morag Myerscough, Dan Thomas, Charlie Thomas
PHOTOGRAPHER: Alan Newnham
ILLUSTRATOR: Elizabeth Frazer Myerscough

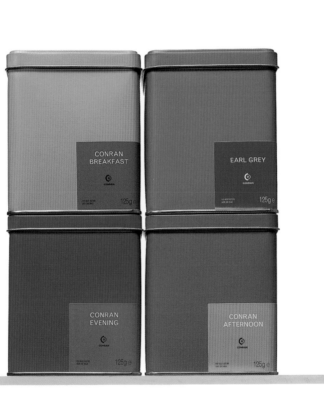

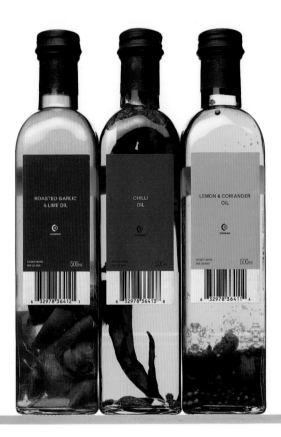

Going to the dentist never felt so stylish after Studio Myerscough created the visual identity and interior design for Lund Osler, a dental-services office in London. This promotional booklet for the firm evokes freshness and good health—not cavities and drills.

DESIGNERS: Morag Meyerscough, Gavin Ambrose
PHOTOGRAPHER: Richard Learoyd
COPYWRITER: Joe Kerr

LUND OSLER
dental health care

Studio Myerscough's visual-identity scheme for Bute, a manufacturer of industrial textiles, gives the company an updated, coordinated look at once contemporary and stylish but comfortably unflashy.

DESIGNERS: Morag Myerscough, Chris Merrick, Gavin Ambrose

PHOTOGRAPHER: Richard Learoyd

bute

Bute Fabrics Limited	Rothesay	T 00 44 (0) 1700 503734
	Isle of Bute	F 00 44 (0) 1700 504545
	PA20 0DP	E sales@butefabrics.co.uk
	Scotland	

Bill Hassall B.Sc. C.A.
Financial Director

PRINCIPAL: Rob O'Connor
FOUNDED: 1981
NUMBER OF EMPLOYEES: 10

6 Salem Road
London W2 4BU
TEL (44) 171-229-9131
FAX (44) 171-221-9517

When Rob O'Connor left the art department at Polydor Records to set up Stylorouge in 1981, post-punk dance-rock dominated the clubs, self-conscious post-modernism found expression in the eclectic forms of Memphis furniture, and Neville Brody was emerging as the type-innovating art director to watch at *The Face,* Britain's hip magazine of pop music and fashion. Behind the anonymity of the name Stylorouge (in French, literally "red pen"), O'Connor could easily bring in freelance collaborators and expand the company at his own pace. From the start, he took on music-related assignments, including album covers and other materials for such acts as Level 42, Siouxie and the Banshees, Squeeze, George Michael, and Simple Minds. Personally familiar with the fickle nature of the music industry, he purposefully avoided creating a reigning house look. "I enjoy working in many different styles," O'Connor says. At Stylorouge, as at many other firms, senior art directors tend to interact more closely with clients; at the same time, a genuine sense of teamwork prevails, and more experienced and younger designers work together on projects, sharing ideas, learning from each other and often turning up unexpected results. The range of Stylorouge's designs is diverse, featuring lush, dense photomontages; powerful, illustrative photography (as in a poster for the movie *Shot Through the Heart*); and hand-drawn illustration from the child-like and abstract (record covers for Jesus Jones) to the elegantly ornate (Kula Shaker's *Hey Dude* CD cover).

STYLOROUGE

Stylorouge's portfolio boasts a wide and diverse range of approaches to illustration and photography; founder Rob O'Connor eschews the limitations of a single house style. Here, a lush, ornate look distinguishes the cover of a CD single by Kula Shaker on Columbia Records.
ART DIRECTOR: Rob O'Connor
DESIGNERS: Tony Hung, Julian Quayle
PHOTOGRAPHER: David Scheinmann
IMAGE MANIPULATION: Julian Quayle

Brightly colored photo details of
highly textured surfaces—plants,
basketballs—give energy and
variety to a packaging series for
KMI's 24 Seven, a body spray
for men.
CREATIVE DIRECTOR: Rob O'Connor
ART DIRECTORS: Andy Huckle,
Tony Hung

Stylized photo images of David
Bowie are brought together in a
stunning persona portrait for the
cover of a greatest-hits collection
on EMI Records. The left half of
the singer's face is from a photo
dating from Bowie's early-1970s,
glam-rock period; the right half is
from a photo from his space-age

Stylorouge subverted movie-promotion formulas with its now classic poster for the controversial British film *Trainspotting* (1996). With its bright-orange type, set in Helvetica bold, and in-your-face, black-and-white pictures of the color movie's weird main characters, it has become emblematic of this design studio's predictable unpredictability.

ART DIRECTORS: Mark Blamire, Rob O'Connor

PHOTOGRAPHER: Lorenzo Agius

Trainspotting 18

THIS FILM IS EXPECTED TO ARRIVE...

23:02:96

From the team that brought you Shallow Grave

#1 RENTON

#2 BEGBIE

#3 DIANE

#4 SICK BOY

#5 SPUD

Perestroika is Stylorouge's name for its Web site, which features a brief history of the design studio, souvenir t-shirts, and its creative manifesto. "We aim to be original (at best), appropriate (at least), and reliably productive (often)," the online mission statement declares.

CREATIVE DIRECTOR: Rob O'Connor
ART DIRECTOR: Robin Chenery
PHOTOGRAPHER: Robin Chenery

PERESTROIKA

Stylorouge. on line

- front desk
- t-shirts
- news
- the team
- manifesto
- history
- portfolio
- film/video
- multimedia
- playground
- mailbox
- press

t-shirts

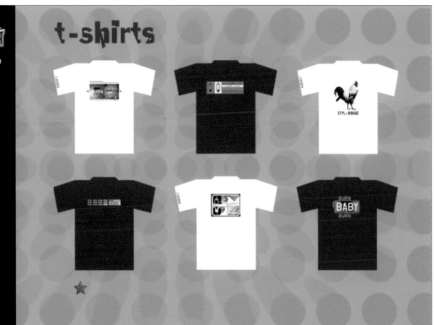

stylorouge

+44 171 229 9131

PRINCIPALS: Swifty

Unit 66, Pall Mall Deposit
124-128 Barlby Road
London W10 6BL
TEL (44) 181-968-1931
FAX (44) 181-968-1932

Widely admired as the funky grand master of contemporary British graphic design, in the mid-1980s Ian Swift was one of the first visual-communication artists in the United Kingdom to embrace and explore the earliest Apple Macintosh's potential. His work and influence have been prominent for more than a decade. A down-to-earth, affable Northerner from a town near Liverpool, "Swifty," as he is known to friends, business associates, and the public, studied at Manchester Polytechnic. Just before graduation, he landed a job at the bible of eighties style *The Face* after its art director, that era's design star, Neville Brody, visited the college, reviewed students' portfolios and soon called Swifty back. An irrepressible experimenter, Swifty reveled in each new assignment, designing pages and whole sections of both *The Face* and its newer, sister magazine, *Arena*, whose art director he became in 1990. "It was all very hands-on, and working with Neville, I really learned about how type could be drawn, shaped, crafted," Swifty recalls. "A lot of this was done *without* the computer, not like it's done today." Considering this background, not surprisingly, Swifty's work has had strong links to Britain's cutting-edge dance-rock and jazz music scenes; he has created bold, recognizable, consistent graphic-design looks in logos and promotional materials for the jazz fanzine *Straight No Chaser,* for the record label Talkin' Loud, and for numerous dance-club events. "I'm interested in work that can encapsulate an attitude, an energy, a style," explains Swifty, whose designs seamlessly meld and exuberantly rejuvenate sources and techniques as diverse as classic 1950s jazz-album covers, sixties movie posters, and photocopier-manipulated letterforms. Still a generous mentor to younger designer-collaborators who apprentice unofficially in his studio, Swifty now markets his own typefaces and limited-edition, fine-arts graphics over the Internet and has moved into the field of motion graphics.

SWIFTY TYPOGRAFIX

GUNSHOT SET IN 164PT

Since the early days of his professional career at *The Face* and *Arena*, whose looks the 1980s type innovator Neville Brody had distinctively established, Swifty has created his own highly expressive, dramatic display typefaces. Some are developed through vigorous technical experimentation, such as repeatedly photocopying and manipulating drawn-and-revised letterforms. Often they are inspired by display faces from 1950s jazz-record covers or 1960s movie posters whose lines, energy, and spirit Swifty finds worthy of revisiting from a respectful—never an ironic or merely gimmick-minded—point of view.
ART DIRECTOR: Swifty
DESIGNER: Swifty

abcdef
ghijklmno
pqrstuv
wxyz

Coltrane set in 164pt

Many of Swifty's music-related designs echo—but smartly update—the looks of classic album-cover graphics of the fifties, sixties, and seventies, as in these covers for recordings on various new-jazz labels.
ART DIRECTOR: Swifty
DESIGNER: Swifty

Enter BRISTOL!

Bristol's breakbeat massive earned a place in global consciousness via Reprazent's 'New Forms' and as a new era evolves, through their own Full Cycle set up, they continue to ➤

STORY Maxine Kabubi / PHOTOGRAPHY Annie Peel

The Dragon

32

33

NOUVEAU FRENCH CINEMA

RACISM, VIOLENCE, BOREDOM, UNEMPLOYMENT, CRIME, FRUSTRATION, POLICE BRUTALITY

LA HAINE, KRIM, ETAT DES LIEUX AND RAI ARE ALL UNCOMPROMISING CINEMATIC VENTURES BY YOUNG FILM-MAKERS THAT EXPLORE THE UNDERBELLY OF FRENCH SOCIETY, LE BANLIEUE – THE SUBURBS, WHERE LIBERTÉ, EGALITÉ AND FRATERNITÉ TAKE A BACK SEAT TO ANTI-TERRORIST CRACKDOWNS AND THE INSTITUTIONALISED RACISM OF THE CHIRAC GOVERNMENT. ➤

Story: PAUL MYERS / Photography: JEAN-BERNARD SOHIEZ

EXPOSED

34 STRAIGHT NO CHASER

STRAIGHT NO CHASER 35

For *Straight No Chaser*, a British magazine about cutting-edge jazz, established in 1988, Swifty has long served as art director, creating dramatic layouts that employ his own original display typefaces. "The magazine has given me a great forum for trying out new ideas and working out a style," Swifty observes.

ART DIRECTORS: Swifty
DESIGNER: Swifty

Starting with copious, sometimes brush-drawn sketches, Swifty develops logos that reveal strong affinities to generic corporate-identity and pop-entertainment graphics of the fifties, sixties, and seventies. But as in his development of a logo for the record label Black & White, he infuses his designs with concentrated energy—almost a kind of visual rhythm—that prevents them from becoming static, retro-kitsch medallions.

ART DIRECTOR: Swifty

DESIGNER: Swifty

Swifty has created, in close association with several hip jazz-record labels such as Talkin' Loud, vibrant corporate identities defined equally by powerful logos and by Swifty's artistic use of the language of visual style. Here, his sliced-through typeface on an album cover, which appears in numerous projects, was inspired by the typographic expressionism of display faces in classic movie posters.

ART DIRECTOR: Swifty

DESIGNER: Swifty

12"MIX/**SLAM** VOCAL MIX/**SOMA** DUB INSTRUMENTAL MIX

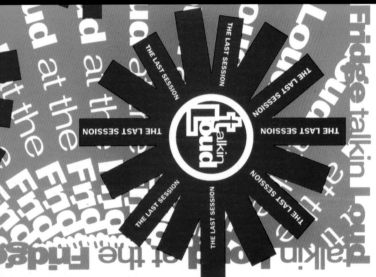

Small, ephemeral, and ubiquitous, colorful flyers like these advertise weekly theme parties or special events at London dance clubs— and provide an important career launching-pad for designers starting out working on highly visible, music-related assignments. "I did loads of them when I was getting started," Swifty recalls, "and used flyers to work out my ideas and help establish a look or brand identity for my clients, who were often record companies that sponsored club nights." As in the selection shown here, Swifty's original typefaces are always the strong central elements in his flyer designs.

ART DIRECTOR: Swifty
DESIGNER: Swifty

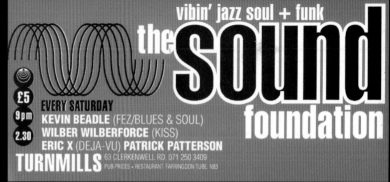

vibin' jazz soul + funk
the **sound** foundation
£5
EVERY SATURDAY
9pm
KEVIN BEADLE (FEZ/BLUES & SOUL)
2.30
WILBER WILBERFORCE (KISS)
ERIC X (DEJA-VU) PATRICK PATTERSON
TURNMILLS 63 CLERKENWELL RD. 071 250 3409
PUB PRICES + RESTAURANT, FARRINGDON TUBE. N83

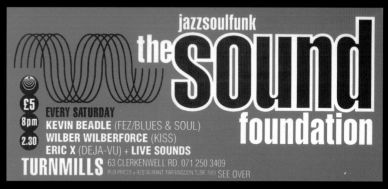

jazzsoulfunk
the **sound** foundation
£5
EVERY SATURDAY
8pm
KEVIN BEADLE (FEZ/BLUES & SOUL)
2.30
WILBER WILBERFORCE (KISS)
ERIC X (DEJA-VU) + LIVE SOUNDS
TURNMILLS 63 CLERKENWELL RD. 071 250 3409
PUB PRICES + RESTAURANT. FARRINGDON TUBE. N83 SEE OVER

flip and trip!
£4 (£3 BEFORE 11PM)
9.30PM TILL 2AM
DJ'S GEOFF WILKINSON & JAMES 'HOLYGOOF' LAVELLE
EVERY FRIDAY
18 KENTISH TOWN RD, CAMDEN TOWN NW1
WKD CAFE

flip and trip!
£5 (£4 BEFORE 11PM)
9.30PM TILL 2AM
DJ'S GEOFF WILKINSON & JAMES 'HOLYGOOF' LAVELLE
EVERY FRIDAY
WEST YARD, CAMDEN LOCK NW1
HQ CLUB

flip and trip!
£4 (£3 BEFORE 11PM)
9.30PM TILL 2AM
DJ'S GEOFF WILKINSON & JAMES 'HOLYGOOF' LAVELLE
EVERY FRIDAY
18 KENTISH TOWN RD, CAMDEN TOWN NW1
WKD CAFE

SUN 10TH MAY 1PM -7PM
TALKIN LOUD
AND SAYING SOMETHING
DJ'S GILLES PETERSON/PATRICK FORGE
DINGWALLS REUNION
TALKIN LOUD MEMBERS £4/£5
ALL DAY JUICE BAR + FOOD/BRING YOUR OWN BOOZE
THE PULLIT BUILDING/MOOV-ON
46 JAMESTOWN RD/CAMDEN/NW1

© SWIFTY TYPOGRAPHICS

PRINCIPAL: Alan Kitching
FOUNDED: 1989
NUMBER OF EMPLOYEES: 2

31 Clerkenwell Close
London EC1R 0AT
TEL (44) 171-490-4386
FAX (44) 171-336-7061

Alan Kitching, founder of The Typography Workshop, a studio in a converted Victorian warehouse in London's Clerkenwell district, is one of the great deans of contemporary British graphic design. But his artistry is rooted in the materials and technology of the not-so-distant past. Kitching, who comes from the Northeast, did a six-year apprenticeship as a compositor in the 1950s, studied at the Watford School of Art in the 1960s, and became a master of letterpress printing. His studio features several old, heavy presses and big cases of shallow drawers full of metal and wood type; here, Kitching files his type by character and point size, not by typeface. Even with—or despite—the computer's emergence as graphic design's and publishing's most powerful tool, Kitching, with the attitude of an inquisitive, indefatigable craftsman, has continued to create innovative, highly expressive posters, banners, and even city maps using typography alone. He has published *Broadside*, a self-styled "experiment in typography and printing" that is a journal in the form of a folded, single A4-size sheet. He also has taught at the Royal College of Art, the Glasgow School of Art, and other schools. Kitching established The Typography Workshop in 1989 after working in partnership at Omnific with Derek Birdsall; today, students in all disciplines— painters, sculptors, photographers, graphic designers—head to London to gain exposure to his hands-on methods. Kitching literally prefers to handle type rather than to theorize about it. "You have to accept the materials," he observes. "I can make something new from something old, bring about a fresh look … that you can't get from anything else, be it calligraphy or the computer."

THE TYPOGRAPHY WORKSHOP

"Knowing how to use it is one thing; finding out what can de done with it takes a lifetime," says master typographer and letterpress printer Alan Kitching. Using bold, simple color and different alphabets, he created for the magazine *Cable & Wireless* this typographic illustration for an article called "Mother Tongue."
ART DIRECTOR: Alan Kitching
DESIGNER: Alan Kitching

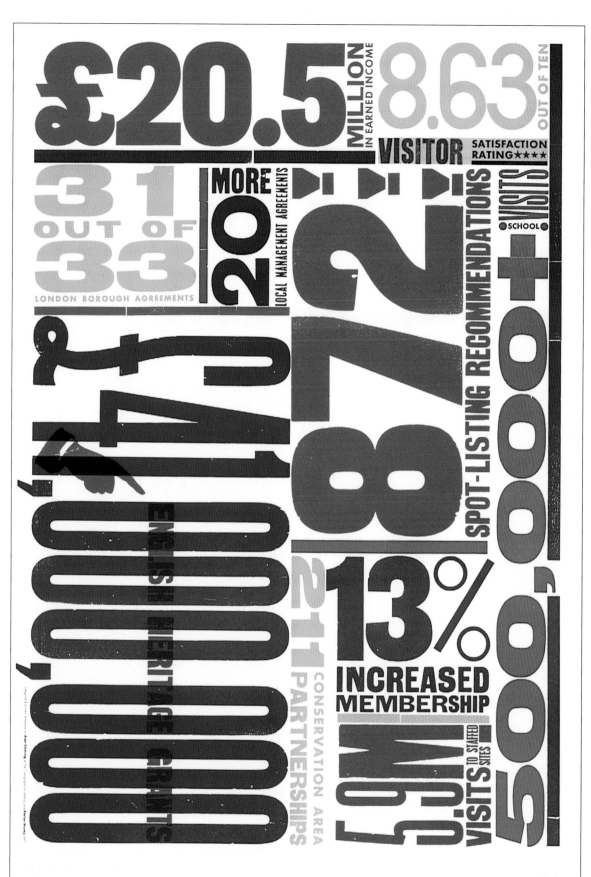

Explosively large letters in an eye-popping primary-color palette energize Alan Kitching's poster, created in conjunction with John Powner at Atelier Works, for English Heritage. Like all of Kitching's designs, it exudes a strong sense of careful craftsmanship.

ART DIRECTOR: Alan Kitching
DESIGNER: Alan Kitching

The expressive power of Kitching's designs is far-reaching and unpredictable, as in this typographic illustration for an excerpt from Dante's *Inferno*. This limited-edition print was executed in six colors on Arches Noir paper.

ART DIRECTOR: Alan Kitching
DESIGNER: Alan Kitching

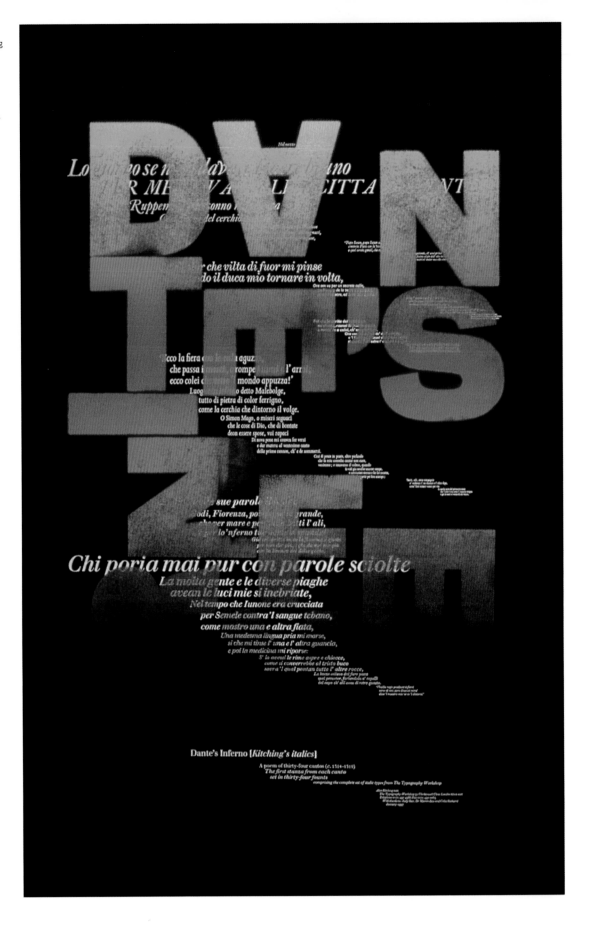

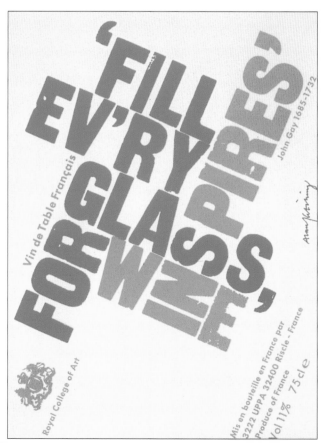

Labels for custom-ordered wine for the Royal College of Art's Senior Common Room burst with the exuberance of Kitching's familiar large, bold display type.

ART DIRECTOR: Alan Kitching
DESIGNER: Alan Kitching

Investment & income

New Library: The People's Network

Skills for the new librarian

Alan Kitching collaborated with John McConnell of Pentagram on the cover and chapter-divider pages for a report titled "New Library: The People's Network," which provides numerous examples of freewheeling, abstract typographic illustration. Here, repetition is as important as bright color in helping to create a sense of depth, rhythm, and drama.

ART DIRECTORS: Alan Kitching, John McConnell

DESIGNERS: Alan Kitching, John McConnell

Healthcare Information | Free

Vitamins, minerals and supplements

Color and varied type sizes give depth and a dynamic rhythm to the cover of an information booklet published and distributed by Boots, Britain's nationwide chain of chemists' shops (drugstores).
ART DIRECTOR: Alan Kitching
DESIGNER: Alan Kitching

PRINCIPALS: Andrew Altmann, David
Ellis, Patrick Morrissey, Iain Cadby,
Mark Molloy, Jon Getz
FOUNDED: 1987

Studio 17
10-11 Archer Street
London W1V 7HG
TEL (44) 171-494-0762
FAX (44) 171-494-0764

Andrew Altmann, David Ellis, and Howard Greenhalgh established Why Not Associates in 1987. Later, Greenhalgh left to set up Why Not Films, and the two companies regularly collaborate on television projects. From the start, the multidisciplinary Why Not Associates studio has taken on each new assignment—from postage stamps and corporate-identity schemes to TV titles and exhibition design—with what it calls "a spirit of optimistic experimentation." That expansive approach is reflected in such projects as its book covers and its "Disturbanisms" lecture-series poster for the Royal College of Art, in which energized fields of photo-abstracted color whip up a technology-minded mood and percolating visual rhythms. Why Not's members work as a close, cohesive team. If some of their creations break with familiar formats—the sensory environments of their Kobe Fashion Museum installations are good examples—they do so to pursue Why Not's aim of "lifting our work beyond the various media that carry the message." Although its designs can challenge and intrigue, its creative team observes that "people are a lot more receptive to adventurous design than they are sometimes given credit for."

WHY NOT ASSOCIATES

Dancing, abstract light forms give a bright sense of gesture to the cover of a book about Why Not Associates' work published by Booth-Clibborn Editions.
DESIGNERS: Andrew Altmann, David Ellis, Patrick Morrissey, Iain Cadby, Mark Molloy, Jon Getz
PHOTOGRAPHY: Rocco Redondo

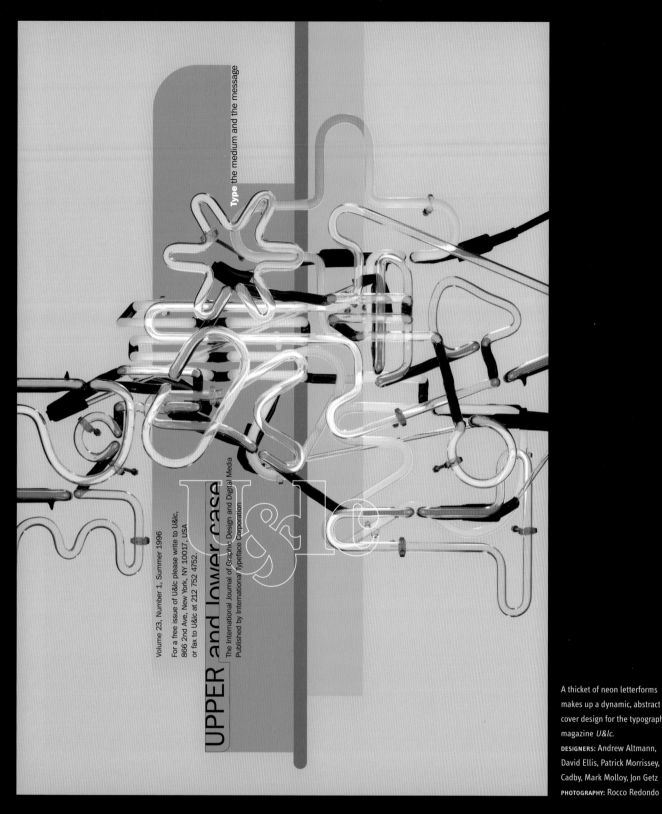

Type the medium and the message

UPPER and lower case

The International Journal of Graphic Design and Digital Media

Published by International Typeface Corporation

Volume 23, Number 1, Summer 1996

For a free issue of U&lc please write to U&lc,
866 2nd Ave, New York, NY 10017 USA
or fax to U&lc at 212 752 4752.

A thicket of neon letterforms
makes up a dynamic, abstract
cover design for the typography
magazine *U&lc.*
DESIGNERS: Andrew Altmann,
David Ellis, Patrick Morrissey, Iain
Cadby, Mark Molloy, Jon Getz
PHOTOGRAPHY: Rocco Redondo

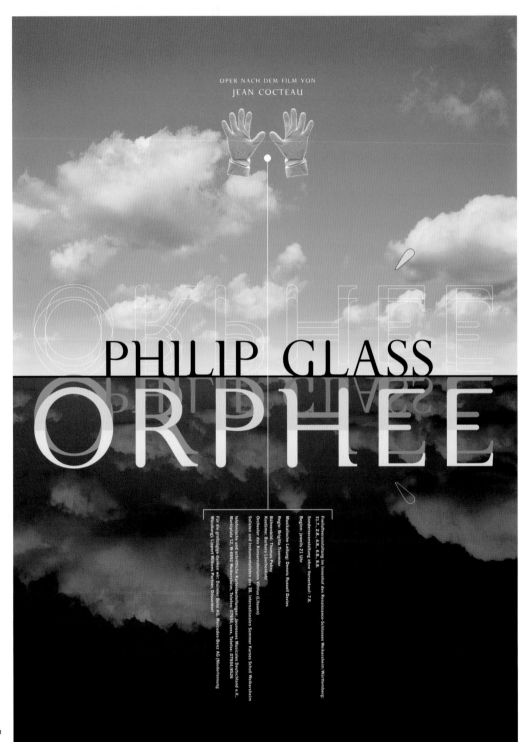

OPER NACH DEM FILM VON
JEAN COCTEAU

PHILIP GLASS
ORPHÉE

Display type reflecting itself along a horizon line is the main, dynamic element in Why Not Associates' poster for a performance of composer Philip Glass's *Orphée*.
DESIGNERS: Andrew Altmann, David Ellis, Patrick Morrissey, Iain Cadby, Mark Molloy, Jon Getz

An abstract photo that evokes the
movement and energy within a
city at night energizes a poster for
a series of lectures on urbanism
topics at the Royal College of Art.
DESIGNERS: Andrew Altmann,
David Ellis, Patrick Morrissey, Iain
Cadby, Mark Molloy, Jon Getz
PHOTOGRAPHY: Rocco Redondo,
Photodisc

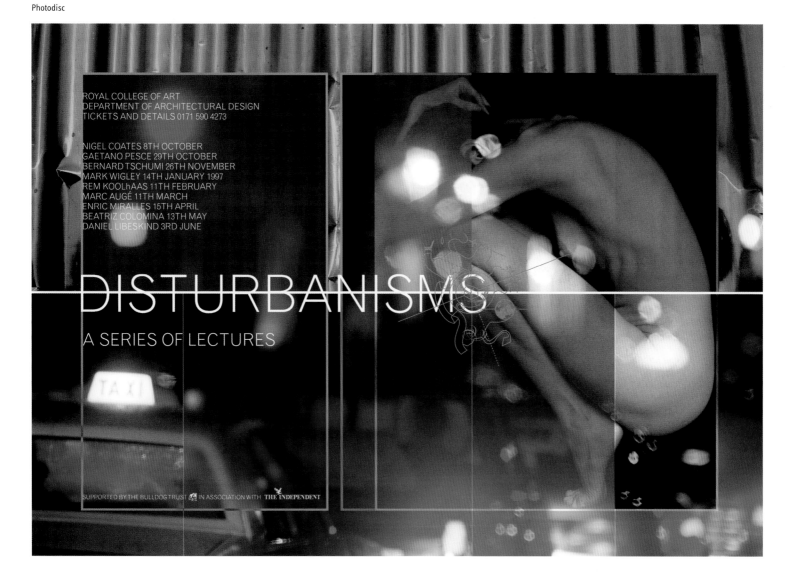

ROYAL COLLEGE OF ART
DEPARTMENT OF ARCHITECTURAL DESIGN
TICKETS AND DETAILS 0171 590 4273

NIGEL COATES 8TH OCTOBER
GAETANO PESCE 29TH OCTOBER
BERNARD TSCHUMI 26TH NOVEMBER
MARK WIGLEY 14TH JANUARY 1997
REM KOOLhAAS 11TH FEBRUARY
MARC AUGÉ 11TH MARCH
ENRIC MIRALLES 15TH APRIL
BEATRIZ COLOMINA 13TH MAY
DANIEL LIBESKIND 3RD JUNE

DISTURBANISMS

A SERIES OF LECTURES

TAXI

SUPPORTED BY THE BULLDOG TRUST IN ASSOCIATION WITH THE INDEPENDENT

For the Kobe Fashion Museum in Japan, Why Not Associates created unconventional audio-visual installations that stimulate the senses in a complete environmental experience. They also convey information in thematic sections about the diverse influence and inspirations that nourish a clothes designer's imagination.

DESIGNERS: Andrew Altmann, David Ellis, Patrick Morrissey, Iain Cadby, Mark Molloy, Jon Getz

PHOTOGRAPHY: Rocco Redondo, Photodisc, Richard Wolf, Hulton Deutch

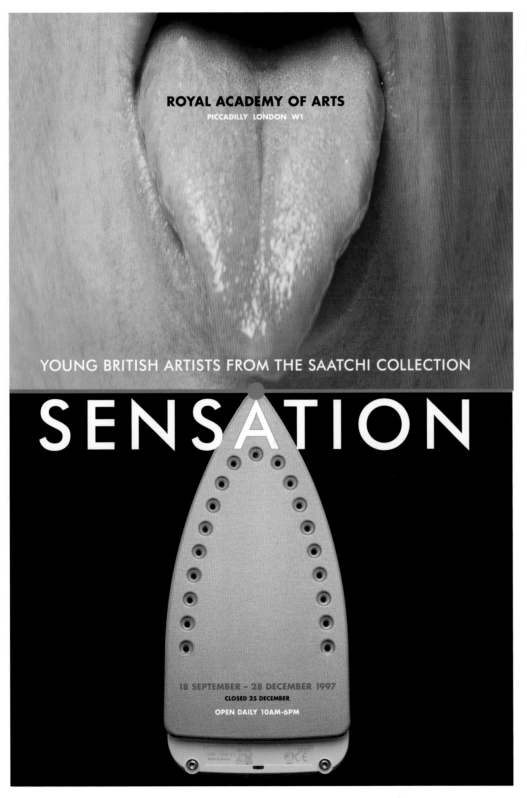

ROYAL ACADEMY OF ARTS
PICCADILLY LONDON W1

YOUNG BRITISH ARTISTS FROM THE SAATCHI COLLECTION

SENSATION

18 SEPTEMBER – 28 DECEMBER 1997
CLOSED 25 DECEMBER
OPEN DAILY 10AM-6PM

Sharp wit and a powerful mirroring of triangular forms grab a viewer's attention to this poster for an exhibition of British contemporary art at London's Royal Academy of Arts. **DESIGNERS:** Andrew Altmann, David Ellis, Patrick Morrissey, Iain Cadby, Mark Molloy, Jon Getz **PHOTOGRAPHY:** Rocco Redondo, Photodisc

PRINCIPALS: Brian Boylan, Doug
Hamilton, Kate Manasian, John
Williamson, Charles Wright
FOUNDED: 1965
NUMBER OF EMPLOYEES: 150 in
England, Spain, and Portugal

10 Regents Wharf
All Saints Street
London N1 9RL
TEL (44) 171-713-7733
FAX (44) 171-713-0217

The scope of Wolff Olins's activity makes it something more than a design consultancy. Specializing in brand development and strategy, and in the creation of comprehensive identity schemes, its projects have increasingly helped blur the lines between the traditional domain of graphic-design studios and advertising agencies. The result can be seen in strongly design-driven, closely coordinated corporate-identity systems and related advertising campaigns, such as Wolff Olins's award-winning project for the launch of British television's Channel 5, or its similarly effective program for Go, British Airways' new low-fare subsidiary. Wolff Olins's creative approach makes much of helping each client define its own compelling vision. Then its graphic designers, architects, multimedia designers, and other experts use design to give visible shape to a client organization's culture and image, all of which they try to express in brand-establishing logos and other materials or media. Wolff Olins's designs can often look simple in a polished way. But as Channel 5's color-fueled system shows, this studio's creative teams also build flexibility into them. That's because, managing director Doug Hamilton notes, "Brands are a bit like children—they grow and sometimes need disciplining."

WOLFF OLINS

Simple, short, and direct, the name Go, which Wolff Olins came up with for British Airways' low-fare European subsidiary, reflects the affordability and ease of use that the new airline strives to deliver. The brand's clear and unfussy, type-driven graphics, used in its corporate-identity scheme and advertising, visually reinforce these values.
CREATIVE DIRECTOR: Doug Hamilton
DESIGNERS: Robbie Laughton, Adam Throup, Joseph Mitchell
PROJECT MANAGER: Jane Speller
PHOTOGRAPHY: Network Photographers

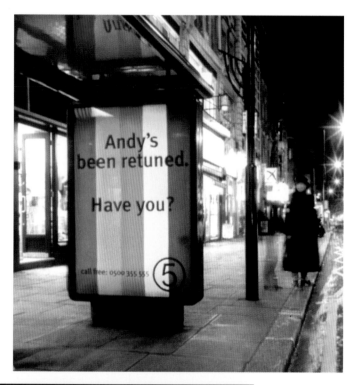

Simple, bright stripes of color that recall a typical color TV screen's test pattern enliven the identity scheme and advertising for Britain's Channel 5.

EXECUTIVE CREATIVE DIRECTOR: Doug Hamilton

CREATIVE DIRECTOR: Robbie Laughton

DESIGNERS: Phil Percival, Daren Cook

PRODUCTION: Adam King

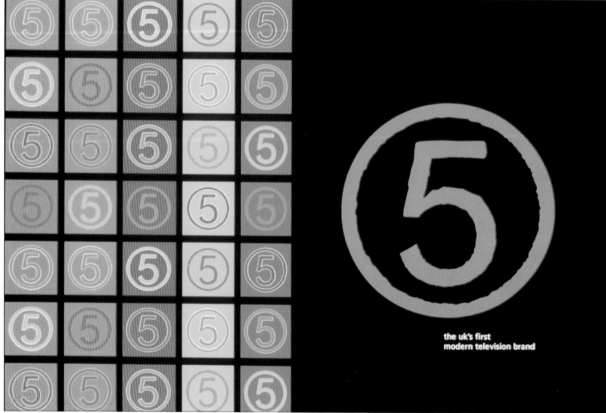

the uk's first
modern television brand

Wolff Olins's dramatic new visual-identity scheme for Odeon Cinemas feels elegant in a fresh, contemporary way and contributes to the sense of spectacle that the exteriors and interiors of movie palaces celebrate.

EXECTUTIVE CREATIVE DIRECTOR:
Doug Hamilton

DESIGNERS: Caroline Schroder, Adam Throup, Emma Cservenka

WEB SITE DESIGNERS: Adam Cavill, Brian Jones

PHOTOGRAPHER: Matthew Weinreb

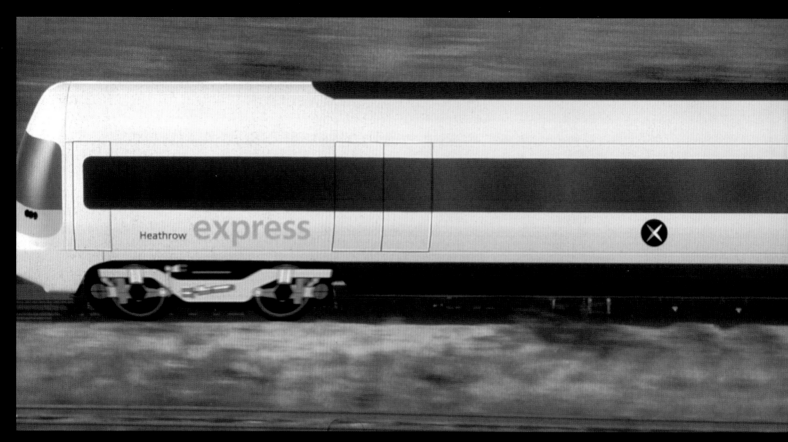

A logo for a train service to and from London's huge Heathrow Airport conveys a sense of high-tech energy, efficiency, and speed.

PRINCIPAL: Brian Boylan

HEAD OF 3-D TEAM: Ian McArdle

ARCHITECTURE AND 3-D DESIGN: Robert Wood, Simon Fraser, Adrian Reed, Martin Hargreaves, Colin Leisk, Robert Elliston, Peter Brown

2-D DESIGNERS: Adam Throup, Jeremy Tankard

PHOTOGRAPHER: Duncan Smith

About the Author

EDWARD M. GOMEZ's background is in philosophy and design; he is a former cultural correspondent for *TIME* in New York, Paris, and Tokyo, and senior editor of *Metropolitan Home*. A contributing editor of *Art & Antiques* magazine, Gomez has also written on art and design for the *New York Times, Metropolis, ARTnews,* the *Japan Times, Condé Nast Traveler, Eye,* and *Raw Vision.* He is one of the contributing authors of *Le dictionnaire de la civilisation japonaise* (Hazan Éditions).

Gomez, who studied at Duke University, Oxford University, and Pratt Institute, is a visiting professor of design history and aesthetics at Pratt Institute in New York. He has won Fulbright and Asian Cultural Council fellowships to Japan for his work on the history of Japanese modern art, and Switzerland's Pro Helvetia award for his writing on the outsider artist Adolf Wölfli. Gomez has lived and worked in England, France, Italy, Jamaica, and Japan, and is now based in New York.